Painting in Watercolors, Markers, Acrylics, and Gouache

Painting in Watercolors, Markers, Acrylics, and Gouache

English text © Copyright 1994
by Barron's Educational Series, Inc.
Original title of the book in Spanish is "Pintura a la Acuarela,
Rotuladores, Acrilica y a la Aguada"
© Copyright 1992 by Parramón Ediciones, S.A.
Published by Parramón Ediciones, S.A., Barcelona, Spain
First edition, January 1992

Author: Parramón Ediciones Editorial Team
Illustrators: Parramón Ediciones Editorial Team

All inquiries should be addressed to:
Barron's Educational Series, Inc.
250 Wireless Boulevard
Hauppauge, New York 11788

Library of Congress Catalog Card No. 93-6203

International Standard Book No. 0-8120-1926-1

Library of Congress Cataloging-in-Publication Data
Painting in watercolors, markers, acrylics, and gouache.
 p. cm. — (The complete course on painting and drawing)
 ISBN 0-8120-1926-1
 1. Painting—Technique. 2. Mixed media painting—
Technique. I. Barron's Educational Series, Inc. II. Series.
ND1500.P25 1994
751.4—dc20 93-6203
 CIP

Printed in Spain
4567 9960 987654321

Contents

THE INK WASH. Three examples of works with a reed pen. Ink wash with reed pen line work. 6

WASH WITH COLORED INKS. Two examples from M. Ferrón. 14

INK WASH PRESERVING AREAS OF WHITE. An interesting proposition. 22

MIXED-MEDIA: WASH WITH MARKER PENS. Techniques. 30

MARKER PENS AND INK WASHES. Two examples from a master of the medium. 38

WATERCOLOR AND PENS ON CANVAS BOARD. 46

WATERCOLOR. AN ABSTRACT LANDSCAPE. Three examples from masters of the medium. 54

WATERCOLOR PAINTING. A SEASCAPE. Two examples from masters of the medium. 62

WATERCOLOR PAINTING. A VILLAGE SCENE. Four examples from masters of the medium. 70

WATERCOLOR, PRESERVING AREAS OF WHITE. Three examples from masters of the medium. 78

WATERCOLOR. FISHING PORT. Two examples from masters of the medium. 86

PAINTING WITH ACRYLICS. LANDSCAPE. 94

USING HOMEMADE ACRYLIC PAINTS. Still life. 102

ACRYLICS. AN URBAN LANDSCAPE. 110

ACRYLICS. FIGURE DRAWING. 118

The ink wash

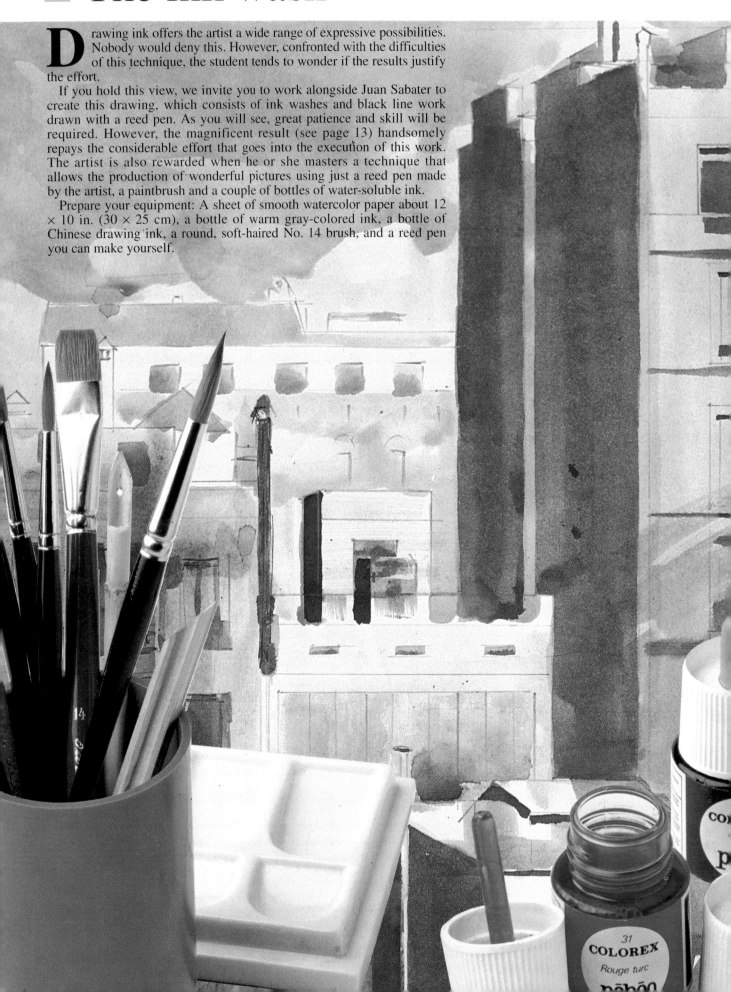

Drawing ink offers the artist a wide range of expressive possibilities. Nobody would deny this. However, confronted with the difficulties of this technique, the student tends to wonder if the results justify the effort.

If you hold this view, we invite you to work alongside Juan Sabater to create this drawing, which consists of ink washes and black line work drawn with a reed pen. As you will see, great patience and skill will be required. However, the magnificent result (see page 13) handsomely repays the considerable effort that goes into the execution of this work. The artist is also rewarded when he or she masters a technique that allows the production of wonderful pictures using just a reed pen made by the artist, a paintbrush and a couple of bottles of water-soluble ink.

Prepare your equipment: A sheet of smooth watercolor paper about 12 × 10 in. (30 × 25 cm), a bottle of warm gray-colored ink, a bottle of Chinese drawing ink, a round, soft-haired No. 14 brush, and a reed pen you can make yourself.

Three examples of work with a reed pen

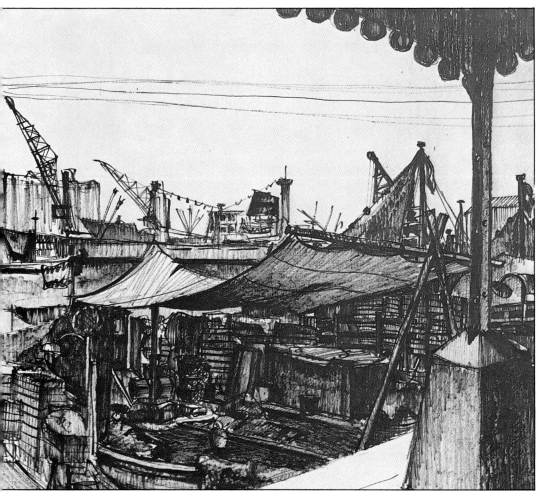

Left. "Fishermen's wharf, Barcelona." Drawing created by Francesc Florensà created by using a reed pen on Canson cartridge paper. Study the wide variety of tones the artist achieved by regulating the quantity of ink held in the pen.

Below. Two more reed pen drawings by the same artist on Schoeller paper. The outstanding features are the simplicity of technique used in drawing the mountain village and the precision of the outline plus light and shade of the worm-eaten door planks, touched up with strokes of the pen.

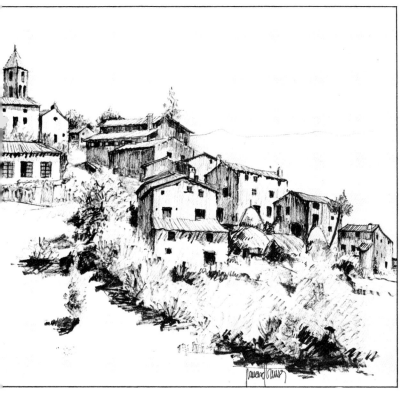

Ink wash with reed pen line work

Step 1
Introduction of the subject and outline drawing

When contemplating this rear view of apartments in the suburbs of Barcelona, Sabater said he first thought of the human phenomena underlying this architectural arrangement: Family, intimacy, the struggles of daily life, human warmth, and so on. Conveying this human equation is not an easy task, especially because the only way to express it is through suggestion of an atmosphere that, to a certain extent, dissolves the rigidity of the structures designed to contain human life. To start, Sabater produces the outline sketch (with HB pencil) you can see on the right. The artist tells us: "I am not embarrassed to admit that I used the ruler for added speed and accuracy in drawing so many straight lines. Rembrandt himself did the same thing without the slightest pang of guilt."

__Right.__ Outline sketch of the subject, drawn with the aid of a ruler. The artist has tried only to define the basic areas of the drawing. Note that, at this stage, Sabater decided to leave out the chimney on the left of the photo.

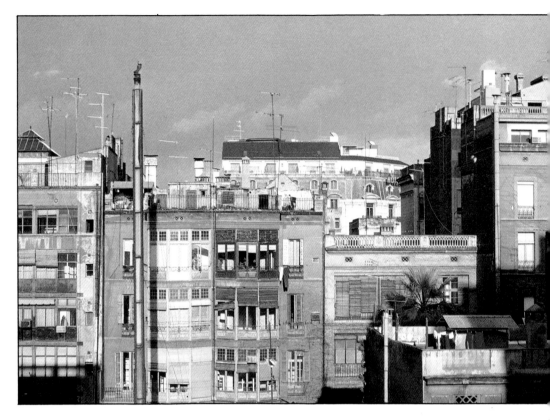

Step 2
Background
wash

Sabater knew that if he produced a good initial sketch, with all the elements of the composition in correct proportion, he would have no problems with the linear aspects of his drawing—that is, with the parts reserved for the reed pen. Using a No. 14 sable brush and fairly diluted gray ink, Sabater covers his outline drawing with a background wash that (in his words) "gives me a first idea of atmosphere."

He has been preoccupied with conveying atmosphere from the moment he decided to undertake the picture, as if everything depended upon achieving this goal. Now he can strive to create the "mood" he requires, by laying down successive washes in the traditional way.

Notice how, even at this early stage, a play between light and shade has been introduced that will carry through to the completed picture. It contributes greatly to the interest and the feeling of depth in the drawing.

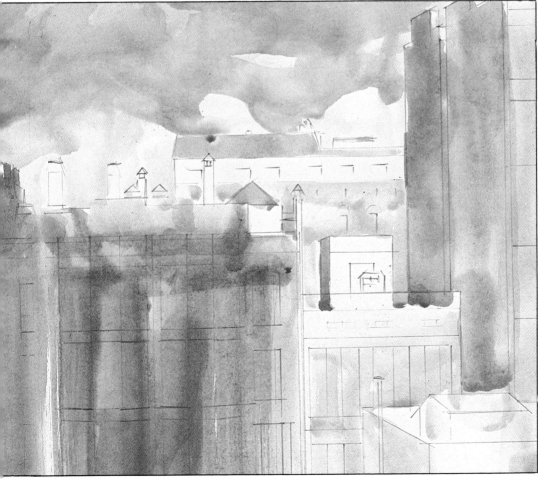

Above. *Action of the brush, applying two washes of different intensity. Note that the darker the wash, the greater the warmth of the gray color.*

9

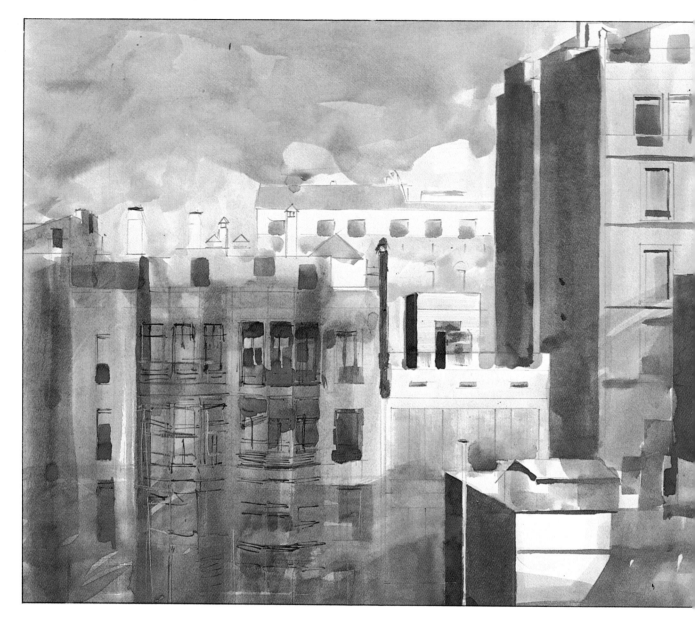

Step 3
Tonal evaluation

At this stage we can confirm a comment made earlier: Atmosphere is an important feature of this picture and must be conveyed, almost exclusively, by the washes of ink.

In fact, if you carefully study the photograph of Juan Sabater's drawing taken on completion of this third stage, you will find no fewer than five different tones, achieved by successive layers of a single wash or (in the darker areas) by brushstrokes of another, much less diluted wash.

You will undoubtedly notice also the greater purity of the white areas compared to the last stage, and perhaps will wonder how these were created, in view of the permanence of ink wash.

Some areas have been whitened with a 50% solution of bleach. Inks that are water soluble

are generally also soluble in chloride solutions such as bleach. Experiment a little and you will find that bleach is a powerful ink solvent and that it also whitens the surface of the paper itself.

To open up white areas in a layer of ink wash, the bleach solution must be applied to a damp surface. If the wash is completely dry, this process will not work as well.

Look closely at the verandas of the buildings in the left half of the picture and you will see the first few linear details.

Above. Sabater's drawing after the completion of step 3. Notice two things: The atmosphere is created by the washes and, secondly, a technical detail—the negative lines on the facades of the buildings have been drawn with a dry tool (such as an unloaded pen nib) on top of the damp wash.

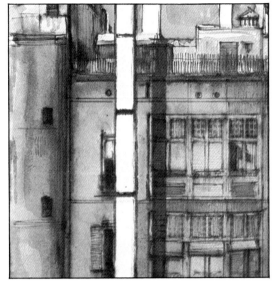

Close-ups

To help you appreciate the successive use of different techniques and the use Sabater made of each one, we laid out this series of close-up photographs in pairs. The pictures on the left show you a section of the drawing during the application of the washes; on the right, the finished picture with all the whites opened up and the black lines superimposed with the reed pen. Remember that whites are produced by using bleach on damp paper, while the black pen strokes must be applied on a dry surface to prevent the ink from running.

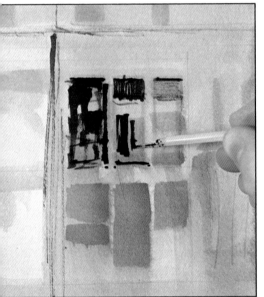

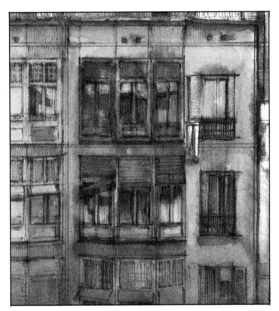

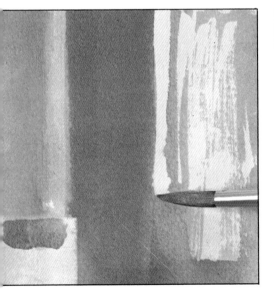

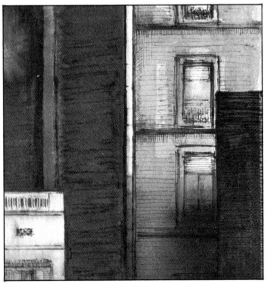

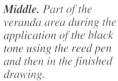

Above. Area centering on the chimney created by the skillful use of the whiting-out process.

Middle. Part of the veranda area during the application of the black tone using the reed pen and then in the finished drawing.

Below. Part of the building on the extreme right of the drawing, photographed during the whiting-out of one area, and in its completed state.

11

Step 4
Reed pen work, whiting out and touching up with the brush

This is, undoubtedly, the longest and most laborious stage, but also the most gratifying. It is during this final stage that the most creative aspects of the drawing must be resolved. On top of the washes created in step 3, Sabater drew in details using black ink applied with the reed pen. At the same time, he opened up whites wherever he thought it necessary and blended shades of gray, where he perceived one area to be too harsh or cold. Notice that in the walls seen from the side, the ink lines were not applied in just any direction, but always toward the corresponding vanishing point. These strokes contribute to a feeling of depth that, in a drawing consisting predominantly of facades, is not easy to achieve.

Finally, the white chimney appears. Sabater says: "I deliberated for a long time before deciding to give the chimney an important role. I even thought about getting rid of it and adjusting the entire layout of the picture. But in the end, its inclusion has provided a frame for the veranda area that, because of its dark tone, was previously a bit overpowered by the whites immediately to the right."

Below. Sabater considered getting rid of the chimney and changing the framework of the picture to focus more attention on the verandas, which present a range of medium tones.

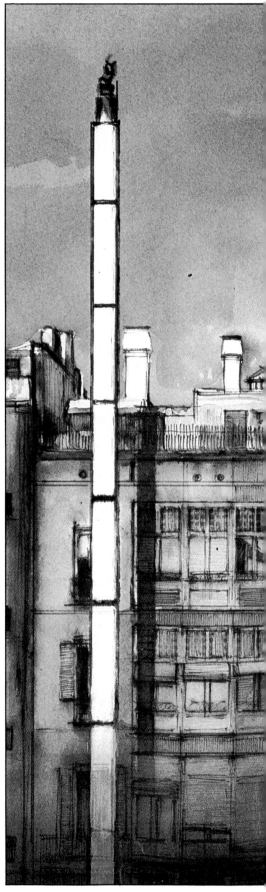

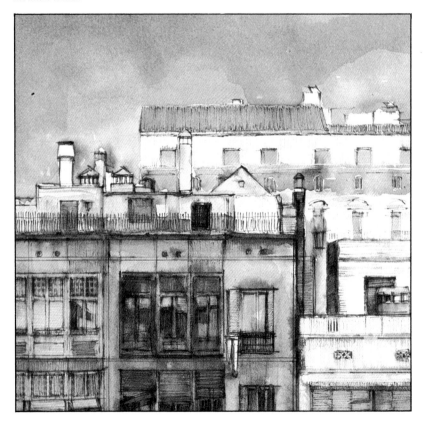

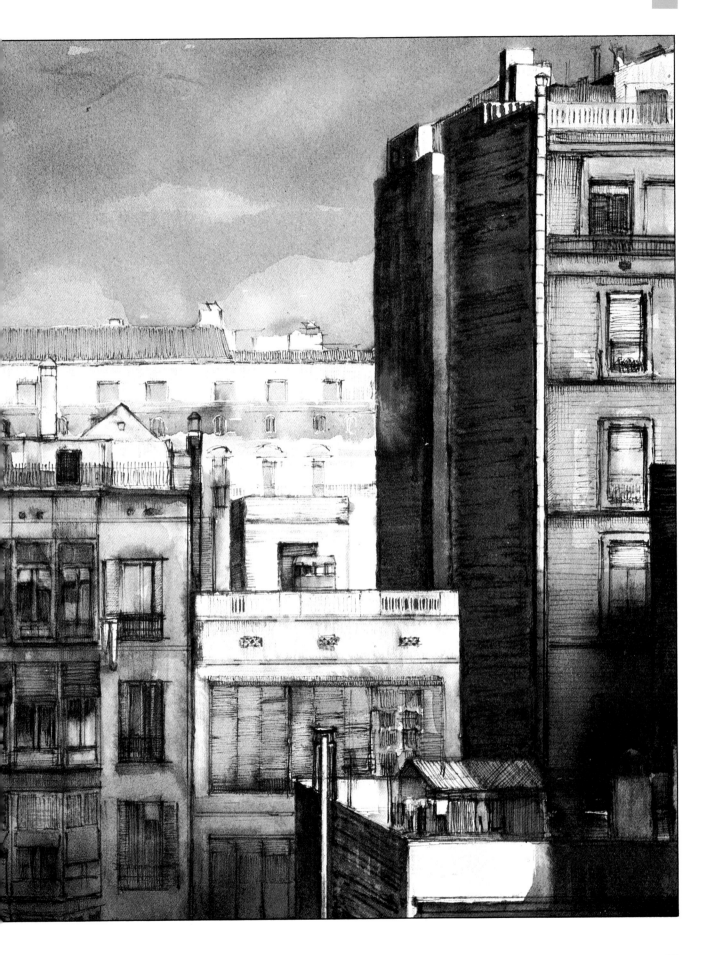

Wash with colored inks

The exercise on the next seven pages, although included with others describing techniques of *drawing* with inks, exhibits all the characteristics of a true painting and uses a technique very similar to that of watercolor. The differences are that inks can produce more intense tones (they can also be extraordinarily transparent) and dry much more quickly than watercolor washes.

Colored inks retain the main qualities of watercolor (their luminosity and transparency), in addition to those unique to drawing ink. Ink is manufactured in such a way that it can be applied directly from the bottle—not only with a brush, but also with a metallic nib or a reed pen. This greatly increases the expressive possibilities of the traditional wash technique, as may be seen in the two examples on the following page, both the work of Miguel Ferrón.

Two examples from M. Ferrón

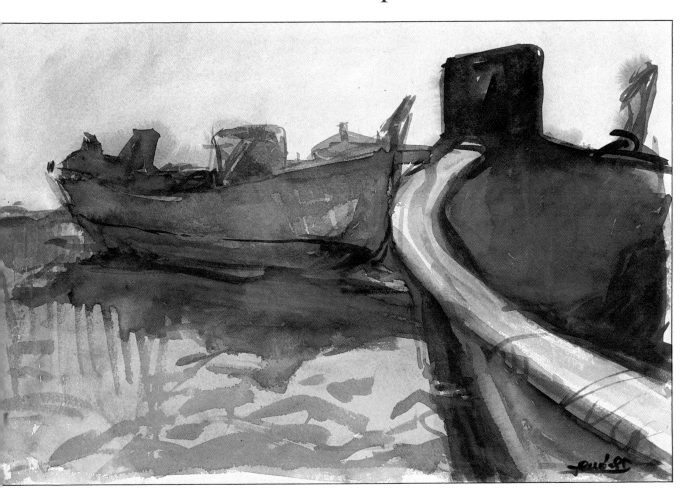

Above. Color sketch of a beach theme, using the ink wash technique. In this picture strong areas of color predominate; linear work is very limited and executed with a brush, the only tool Ferrón has used.

Left. Although it represents a specific subject (the stern of a fishing boat with the propeller hole), this full color wash is, in its concept, an abstract painting. The background color was applied with a wet brush and then gone over with a dry brush to produce the scrubbed effect. A reed pen was used for the rhythmic, linear strokes.

Introducing the subject

We would like to introduce you to a technique (the full color ink wash) that can produce some wonderful results. Follow Ferrón's example: Using this photograph for inspiration, make a study in colored inks. Use a sheet of coated paper about 12½ × 9 in. (32 × 24 cm) of good quality and fairly heavy weight. You can use any brand of good quality inks. The brushes should be fine haired: One flat No. 14 brush and two round ones, Nos. 12 and 6.

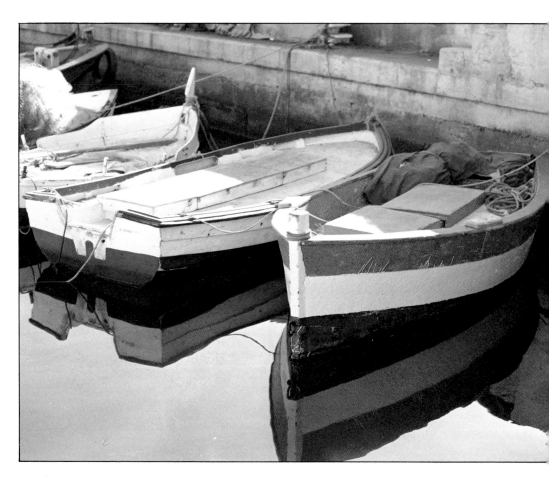

Step 1
Outline drawing

With a blue water-soluble pencil or ink stick, make an outline sketch. Try to copy Ferrón's drawing as closely as possible.

Notice that the reflections were defined with just as much care as the shapes of the boats. Working with a blue water-soluble pencil has an obvious advantage: The water will make the initial sketch lines disappear and any blue tone this might create will not adversely affect the general coloring of the painting.

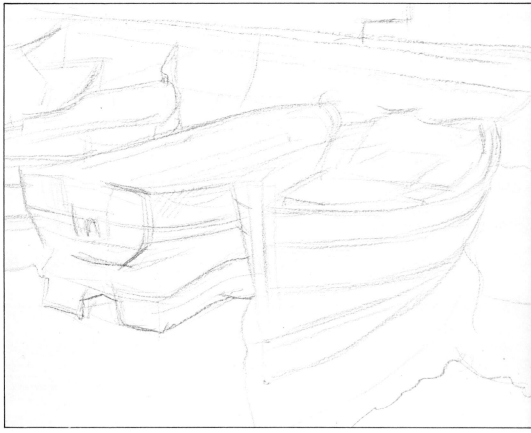

Color scale

This is the range of colors used by Miguel Ferrón. As you can see, he has used just six colors: A cadmium lemon yellow, a red (very similar to magenta), two blues (cobalt and ultramarine), a warm gray, and ivory black.

The presence of three colors like the primaries (yellow, magenta, and blue), in conjunction with the gray and black, allows you to create an infinite range of shades and tonal values. The latter, of course, will depend upon how much water you add to your color mixture.

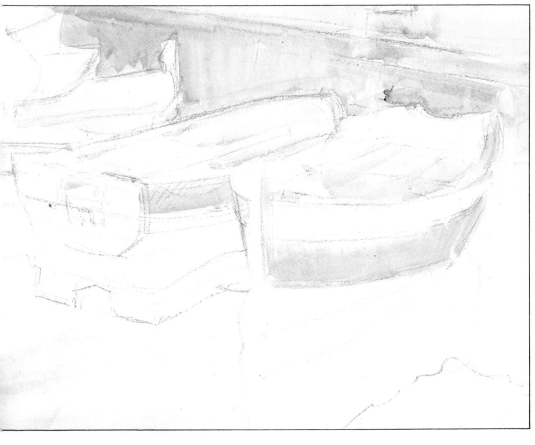

Step 2
First touches

With very dilute washes of ink, color in the areas that appear in shadow. You have to mix the blues with gray to create the three different shades in the illustration on the left.

Notice that the white areas in full sunlight have been left untouched, as have those in the photograph that have a distinct color: The greens, blues, and reddish colors, both on the objects and in their reflections.

17

Step 3
The first areas of color

In this third stage of his colored ink painting, Ferrón has blocked in the dark areas with their actual color. Notice, in the four close-ups on this page, that these are not simply the colors from the basic range, but rather shades obtained by mixing two or three basic colors together. You can see the red was cooled with cobalt blue and that the brilliant green produced by mixing yellow and ultramarine blue was toned down with a hint of warm gray. In the whole picture, photographed below at the end of this third stage, you can see that the only color used in its pure form was ultramarine blue for the sail of the first boat. Throughout this third stage you should work, as Ferrón has done, with fairly diluted washes of ink. Try not to lose the transparent quality of the medium; maintain it right up to the last brushstrokes. Otherwise, you might find that your painting, instead of rejoicing in a wide and subtle range of color, has lost the special quality that only colored inks can achieve.

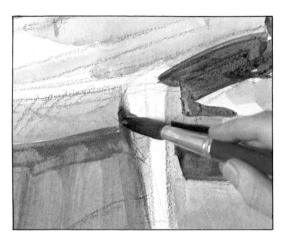

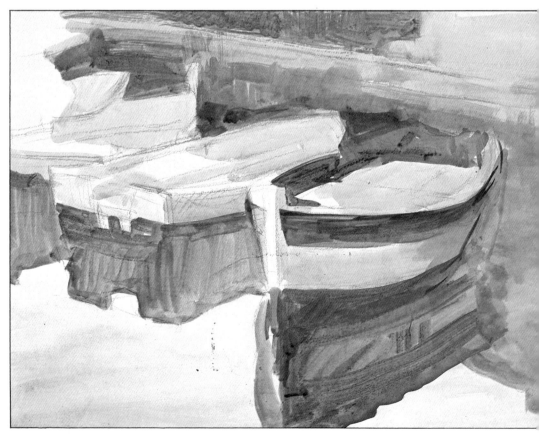

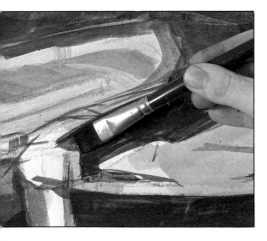

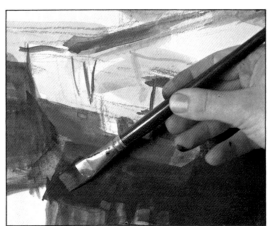

Step 4
Building up color and tonal evaluation

The close-ups on the left show that Ferrón's palette was a white china plate (an extremely practical choice) and that he used a flat, synthetic No. 14 brush. Throughout this stage his objective was on the one hand to establish the definitive tonal contrasts and, on the other, to apply not only the right tone but also the right color to each area of the picture.

If you study each area carefully, you will see that the artist blended the scrubbed strokes of the semidry brush with the smooth washes, all the while maintaining strict control over the tone. Ferrón commented: "I have never been interested in detail; I prefer that the person who sees my work imagines those elements. What really does fascinate me are the variable elements of a picture (volume, composition, color, texture), facets I enjoy seeing appear and mature with each successive stage of the picture's development."

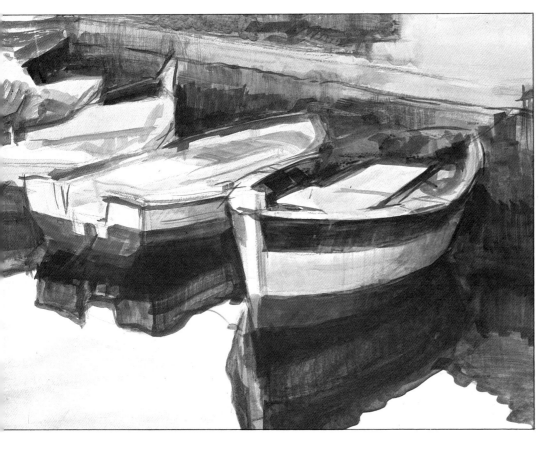

Step 5
Final touches with watercolor

Once dry, the colored inks Ferrón used are insoluble in water. This feature, which throughout the execution of the picture restricted tonal or chromatic alterations, now allows the artist to add a few final touches (very few) using watercolor, without fear of the ink running. The linear details have been added in this way. The ropes, for example, were drawn in with a fine No. 14 brush and fairly thick white watercolor. As it dried, the white pigment was slightly absorbed by the dark tone beneath without being damaging in any way. The two illustrations below demonstrate the process just described.

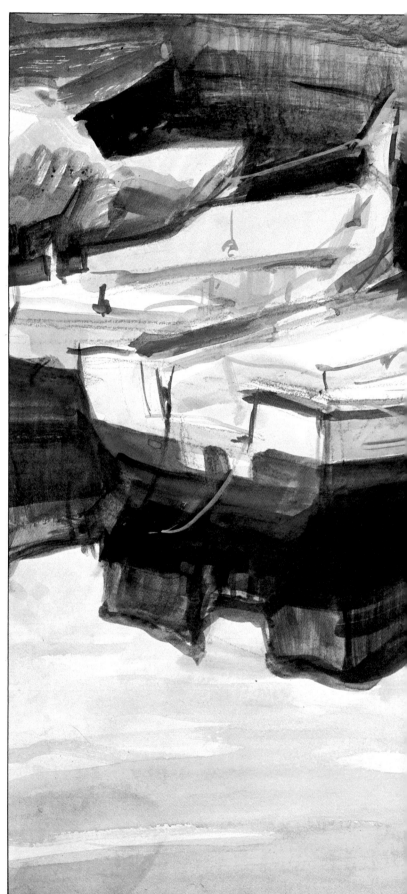

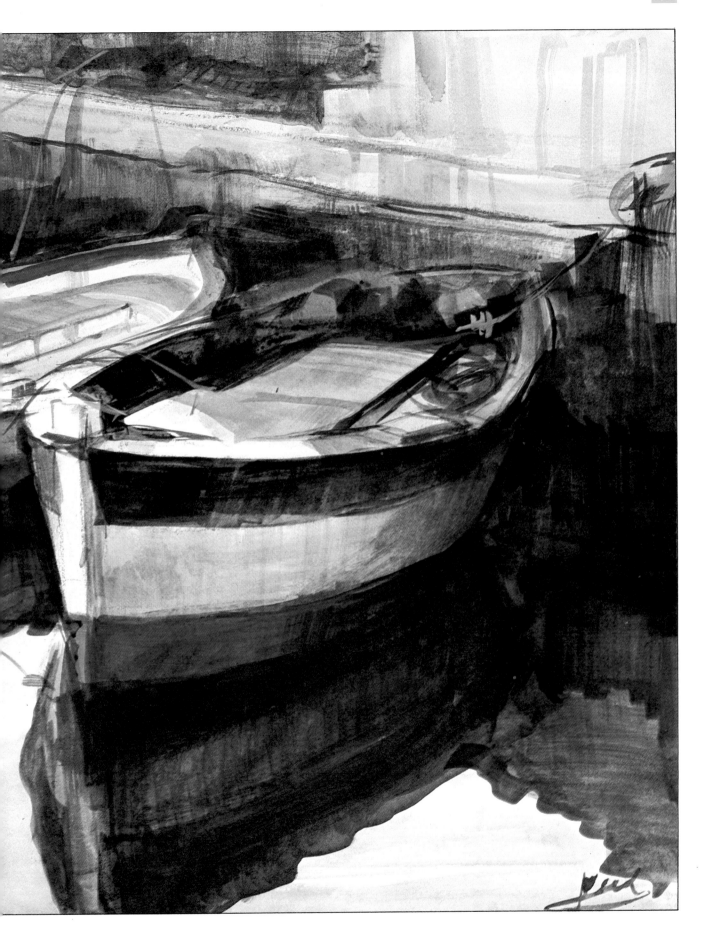

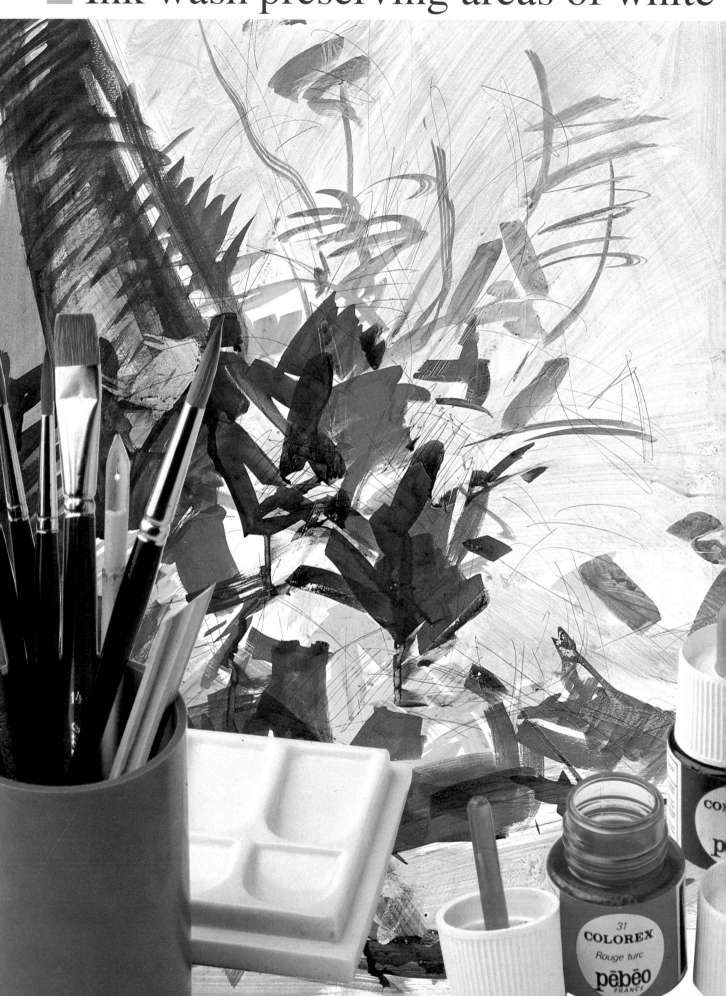

An interesting proposition

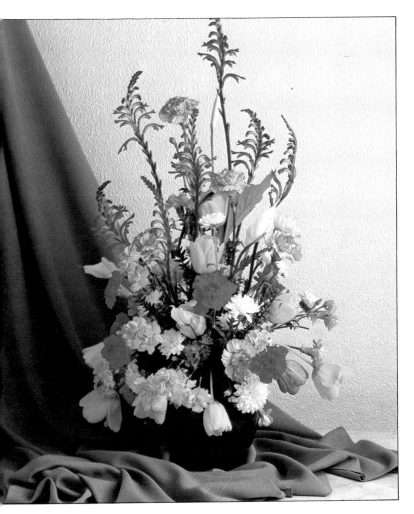

Introducing the subject

This floral composition would certainly have delighted the great David de Heem (1606–1684) who, in his native Holland, painted enormous floral arrangements in which he loved to reproduce the minutest detail. We can imagine what he would have made of this model: A rather gloomy picture in which the flowers would stand out, showing every petal, vein and leaf, in rich and dazzling colors against an improbably dark background. That is what de Heem, in true baroque style, might have done; we now ask you to take a diametrically opposite approach.

We ask you to forget that what you have before you is a bunch of flowers. Concentrate on its color and form; reduce the subject to its basic, abstract composition and tell yourself that you are going to "explain" certain areas of color that occupy a particular space.

The aim is that you put your creative imagination to the test by producing an abstract picture in color. So how is this done? Miguel Ferrón will create an abstract work from this subject to inspire you to produce your own totally different, but equally valid and interesting version.

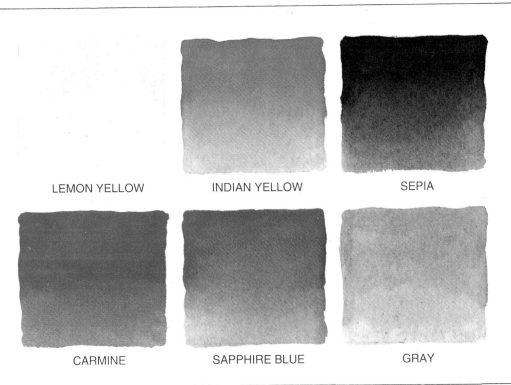

| LEMON YELLOW | INDIAN YELLOW | SEPIA |
| CARMINE | SAPPHIRE BLUE | GRAY |

Left. The range of colors used by Miguel Ferrón in this exercise: Lemon yellow, Indian yellow, sepia, carmine, sapphire blue, and gray. We recommend that you do not depart too far from this basic range; it is easy to turn an abstract vision into a mosaic of color with no real meaning.

As for the inks, choose the brand that best suits your personal tastes and your pocket. However, do make sure that you buy water-soluble inks.

Step 1
Basic layout

Departing from a norm (any norm) that has always been considered sacred requires a great deal of courage. Drawing (or painting) flowers, for instance, is something that can be done with greater or lesser degrees of success, but is always undertaken with the same aim in mind: To create an artistic impression of those particular flowers that conveys to others the same aesthetic response that the observation of the subject inspired in us. However, when an artist tries to achieve something as unconventional as depicting flowers that cease to be flowers (because it no longer matters whether they are or not) and that become simply chromatic impressions, then we enter into the realm of a personal ideology that cannot be judged in theoretical terms. The criteria for success then depend upon the originality of the artist, as well as on certain values that are constant in all works of art: Line, rhythm, balance, form, color, texture, and so on.

Since courage is required, be bold from the

first step: Take a black ball point pen to draw the basic layout of your picture.

Remember that the objective is not to draw flowers and leaves, but to locate on the picture plane areas of color (within an overall scheme, of course), the identities of which are not really important. Be spontaneous with your first few strokes. Allow the pen to follow the direction of your eye without pausing to analyze proportional relationships between the different elements of the subject, or the rhythm of the lines. Your eye will automatically register these. In other words, don't try to be cerebral; have faith that you are more intuitive than you think.

Now do something else: With masking fluid, paint some loose, individual brush strokes in the background and, within the main body of the picture, paint out the areas that you want to leave white.

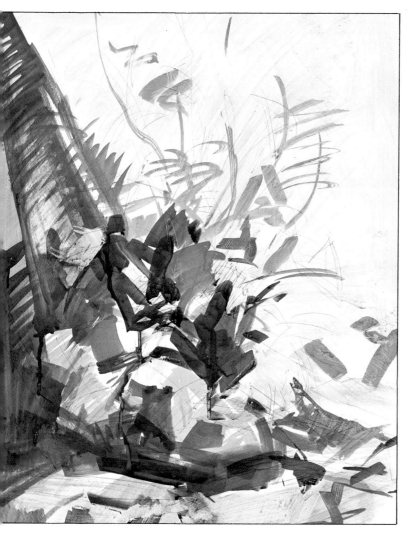

Step 2
The first strokes

It is hard to be decisive. We always believe (and often with good reason) that the first brushstrokes will determine whether the picture will be good, bad, or mediocre. Often, fear of getting it wrong leaves us with the brush in our hand, unable to load it with ink and apply it to the paper. This feeling of helplessness, so common in would-be artists, sometimes has a profound psychological explanation: You can so love your picture that, even before you begin to paint it, the idea of its ending up in the trash is unbearable. In this state of anxiety you are expected to produce a wonderful piece of work—which, inevitably, doesn't happen.

Perhaps we have exaggerated a little, but there is a certain truth in this. You must accept the idea that it's one thing to produce work to learn something and another altogether to create a painting for exhibition. When you are learning, what you draw and paint is just a "laboratory" in which you try out new materials and styles, both technically and conceptually. If the experiment fails, you start again, correcting your mistakes: That's what it's all about.

To sum up: You should throw yourself into this exercise, laying the first areas of color (yellows, reds, and sepias) onto your sketch, without thinking too hard about the forms you are creating.

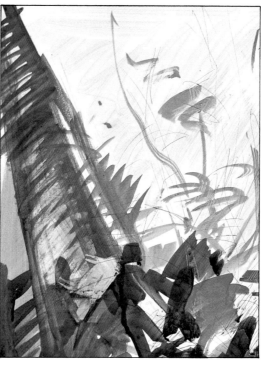

Left. Close-ups of the stage in which the first areas of color are laid in. Notice the complete spontaneity of the strokes but, also, the purpose with which each brushstroke is applied. To cover large areas, Ferrón has used a large brush.

Right. Close-up photographs, taken during the third stage of the painting process. Perfectly defined brushstrokes are added with a flat brush on top of the earlier ones. In the second photo, a poor-quality brush is used to apply masking fluid to the areas we want to show white in the finished picture. Later strokes can be painted on top without fear of losing these protected areas.

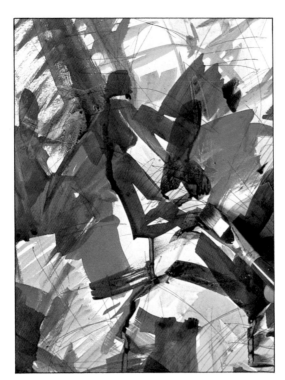
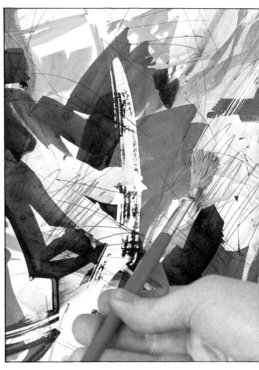

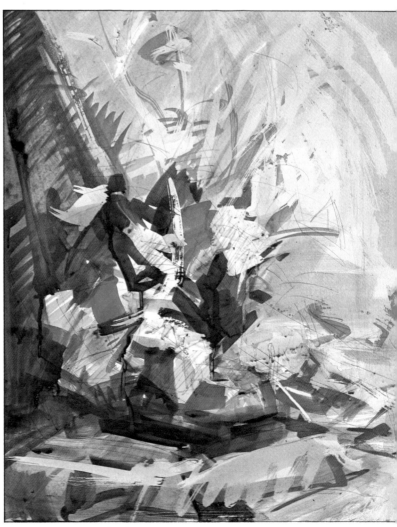

Step 3
Further brushstrokes and preserving areas of white

The objective is to give the painting a rich chromatic quality, and in this kind of work the expressive power is entirely dependent on color and the effects created by the brushstrokes. In other words, the value lies in the mark made by the brushstroke rather than in what it represents.

Color and tonal values are built up by superimposing transparent layers of ink; however, we must do this without detracting from the spontaneity of the later brushstrokes. The artist must be able to apply these later strokes without having to worry about going over whites or areas of the painting in which the tone and color are just right. The most practical way to ensure this freedom is to apply masking fluid to the areas we wish to protect. This way we can then continue adding new brushstrokes without fear of spoiling the reserved areas.

In the four photographs above (on this page and the next), the expressive potential of the brushstroke is clearly demonstrated, irrespective of what they represent.

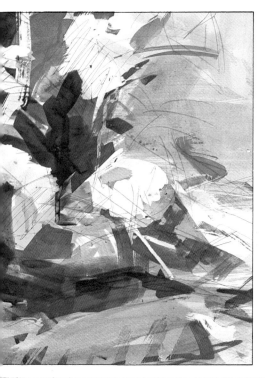
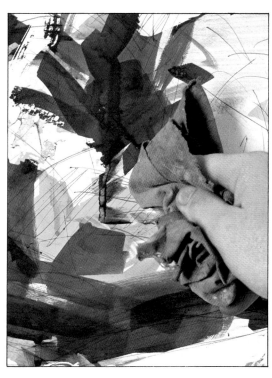

Left. Area of the picture where certain parts have been whited out, and the process of removing the masking fluid from one of these parts.

Once you have added all the strokes you feel necessary for the chromatic unity of your picture (as few as possible if you want to keep life simple), allow the painting to dry completely. When it is dry, take a cloth and rub it over the protected areas of the painting to remove the masking fluid, revealing the whites you previously judged to be essential to the composition.

You can also use an eraser or even a finger to remove the masking fluid, peeling off the sticky layer in little balls.

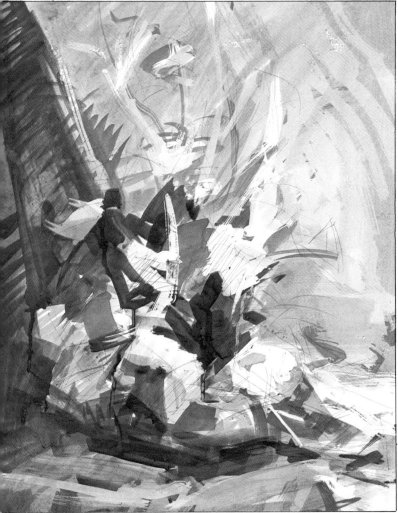

Left. Ferrón's picture after more color has been added (notice the greater variety of yellow shades) and after all the masking fluid applied throughout the development of the painting has been removed.

Step 4
The finishing touches

If you look again at Ferrón's picture as it stands at the end of the third stage, you will see that it is like a vibrant harmony of color—but lacking in rhythm. The central notes of the harmony are a little scattered, needing a melody to bring them together.

Ferrón, in this fourth and final stage, concentrated on uniting the scattered notes by means of an inner rhythm. He achieved this with apparently (only apparently) random strokes of blue ink. This is, in fact, the most deliberate part of the whole work, because the artist had to stop and think about the purpose of each stroke: Its length, its curve, its angle in relation to the vertical. All this worked toward the desired compositional unity, achieving the correct relationship between all the areas of color, allowing us to identify an arrangement of abstract forms with a floral theme—even though the artist never actually drew a flower.

We should add as a footnote that this type of work, close in concept to abstract expressionism, is always a tall order for the beginner.

Right. Close-ups of the lower and middle areas of the finished work, in which you can see how the linear strokes of blue ink have unified the picture. The polygonal shapes described by these strokes on the table surface help to balance the powerful effect of the strokes that carry the eye upward.

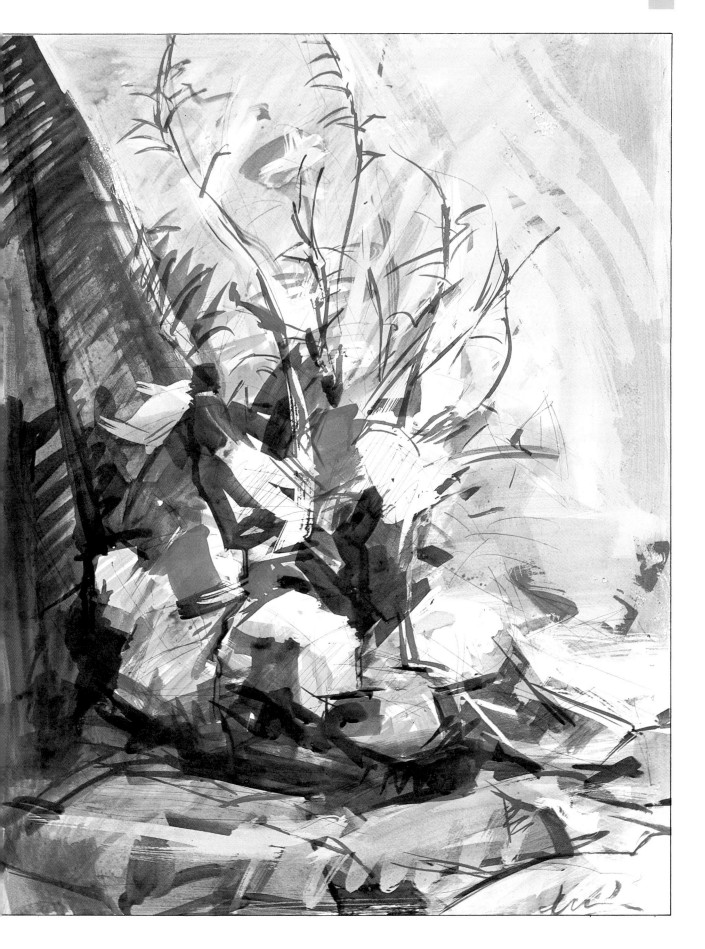

Mixed-media: Wash with marker pens

We have studied different methods of working with colored inks: Traditional washes, background washes, and line-work with reservoir and reed pens. Miguel Ferrón demonstrated that ink washes incorporating reserved white areas may be used for the most demanding of subjects, as with the floral theme shown previously. Now, Miguel is going to treat us to another work produced in his highly personal style, this time using a mixed-media technique.

We will be following, step-by-step, the development of a landscape created with ink washes and marker pens. However, we should note that the way Ferrón uses markers in this painting has little to do with the techniques traditionally recommended for this medium. These will be described briefly on the opposite page.

At this point we should stress something that by now you should recognize: The artist should experiment constantly, not sticking exclusively to traditional techniques when learning to use different media, but rather continually searching for new ways to convey an aesthetic emotion.

What we—with the help of Miguel Ferrón—hope to achieve by inviting you to imitate some highly personal forms of expression, is not so much that you adapt them to your own style. That would be very difficult indeed. Rather, we feel that if you work in an unfamiliar way, new ideas may pop into your head with which you can experiment later.

You should never be afraid to try anything, however crazy that idea you have just had may seem. Before you throw it out, *try* it out— more than once. You never know; without realizing it you might have just had a stroke of genius.

Techniques

Gradations and color blending

If you want to blend two or more colors or two tones of the same color, you will have to work *al fresco,* that is, applying the darker color tone on top of the lighter color before the lighter one has dried. Try to reproduce the gradations shown in this example: Red blending into a very pale raw sienna and a deep blue gradating into a pale and transparent blue.

Superimposing parallel strokes

Strips of sienna, red, and yellow have been built up with uniform strokes into areas of continuous color without any tonal variations; on top of this, parallel strokes of sky blue have been added to create (thanks to the transparency of the blue, rather than by color mixing) a grayish green, a deep carmine, and a luminous, light emerald green.

Parallel strokes and superimposing color

Application of wide parallel strokes is the most frequently used method of covering large surfaces with markers. Changes in the direction of the strokes help to distinguish between planes. Superimposed layers of a single color create tonal changes (see the central area of the example) and the transparency of the colors can also produce chromatic variations.

Combing or raking a surface

When the marker lines follow the form or rhythm dictated by the contours of your subject, this could be described as combing or raking the surface. In this example we have three sets of radial lines that suggest the structure of a flower. Another example would be if, when creating shade on the side of a cup, we followed its curved surface with dark strokes of color, in accordance with perspective.

The subject and its colors

This is our theme. A rural subject, centered around a large house with stone walls and a slate roof (typical of the Pyrenees), framed by various trees and bushes. Ferrón has chosen a vantage point with a head-on view of the subject, in which it is possible to distinguish three separate receding planes. In the sketch at the top of the next page, these can be clearly seen: The vegetation in the foreground leads up the stone wall, another plane comprising this wall and the two trees and, finally, a third plane consisting of the house. The sky and background complete this succession of superimposed planes. In terms of color, it is clear that cool tones predominate; the only really warm tones appear in the earth colors of the illuminated walls and the yellow of the flowers.

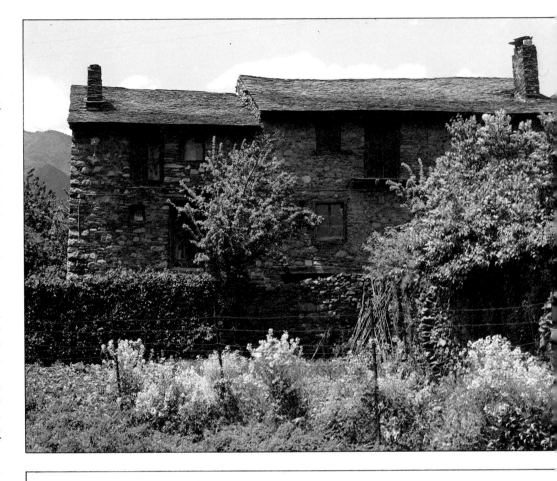

Right. Color chart used by Ferrón in the creation of this highly individualized piece of work: Eight marker colors in the cool range (except for the earth color) and four inks, including yellow.

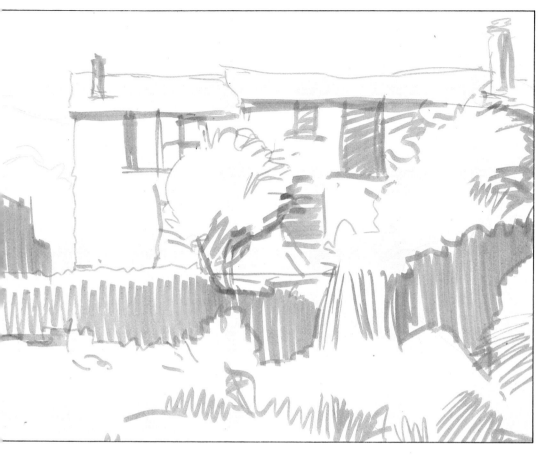

Step 1
Outline drawing

This was referred to on the previous page. Now you can see it in its completed state. It has been drawn using a gray, wedge-shaped marker pen and brings together the basic forms presented by the subject. Because these marker strokes cannot be erased, we recommend that you make an initial, barely visible sketch in HB pencil.

Any alterations can be made at this stage, so that the marker can be used confidently and without hesitation. Remember to erase the pencil lines afterward which, as we said before, should be very faint.

Left. Three close-ups in which you can see the brushwork in the second stage, described on the following page. They show part of the foreground, a little bit of the sky and the tree in the center of the picture, to which Ferrón has added a pleasant, warm tone.

Step 2
Background washes

On the right you can see how the picture looks after Ferrón has covered his outline drawing (Step 1) with ink washes, mixed from the four colors shown on the chart (page 32). If you study the chart, you will soon discover which colors have been used for each wash.

Notice how the lines of the basic drawing intensified after absorbing the dampness of the ink. Mix the blues with the yellow for the foreground greens and the trees. Add a little violet to introduce a cooler tone in a few areas of the vegetation.

This same greenish gray can be used to color the walls of the house. The roofs have been covered with a violet wash tinged with blue. This violet, with a little yellow added, has produced the warm tone of the tree in the middle of the picture. The sky is a wash of pure sky blue.

Right. Close-ups of the third step of this picture in which the black felt tip pen can be seen working on top of the ink wash.

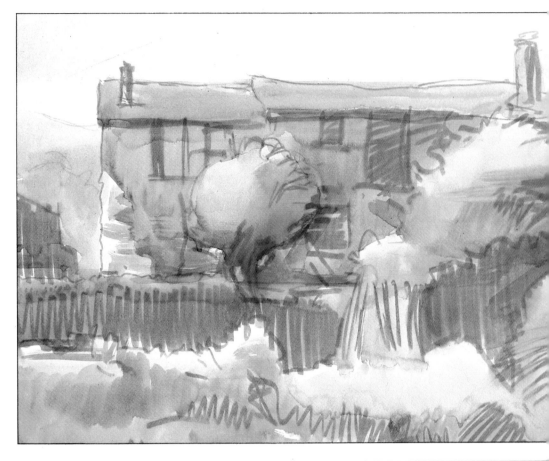

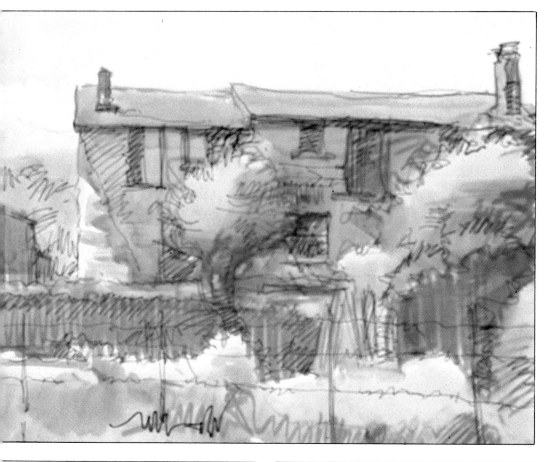

Step 3
Black outlines

Until now, Miguel Ferrón has used ink wash in the traditional way, applying it over an initial drawing made with a marker pen. He might well have continued in the same vein, building up detail and enriching color through successive layers of transparent wash. However, this "normal" solution did not interest Ferrón who, inspired by the Muse on this occasion, was determined to find an original way to finish his painting. In fact, Ferrón admitted to being unsure about the next step. In the end he strengthened the outlines of the different elements using an ordinary black felt tip pen, with which he produced a series of uninhibited strokes, applied on top of the wash, which was still slightly damp.

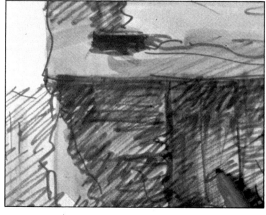

Left. Three close-ups showing how fine felt tip pens are used in the fourth and final phase of Miguel Ferrón's drawing. Look at these close-ups from a distance or through half-closed eyes and you will see how the pen strokes help to synthesize each area of color.

Step 4
Building up color with fine felt tip pens

From the moment the previous stage was completed, Ferrón knew exactly what he wanted to achieve. This was to synthesize the different areas of color by the apparently random use of the felt tip pen; irregular, broken lines, seen from a distance, are converted by the eye into areas of color that appear to be more even. This is similar to what happens with pointillism. With the exception of the background washes, there is not a single square centimeter of uniform color in either the close-up photographs of the previous page or the reproduction of the finished drawing (on the right). The colors are suggested by the lines of the felt tip pen, some fine, others thick; some densely, others more loosely applied. The overall impression is of a drawing with a very special and attractive vibrancy of color.

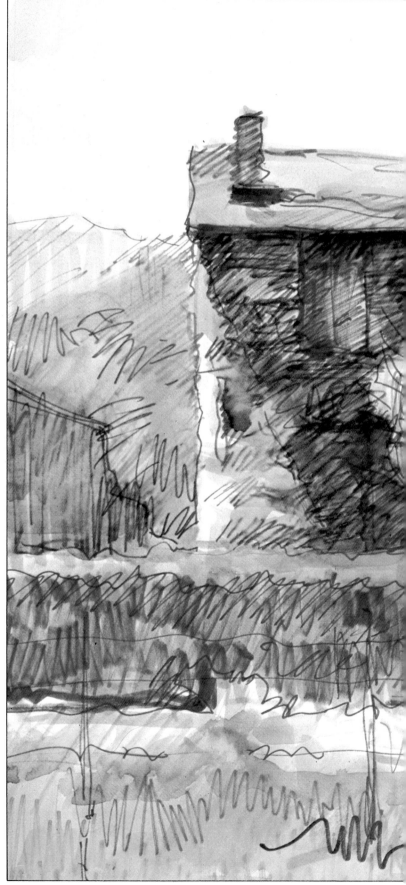

Below. *Reduced size close-up showing how distance has the effect of synthesizing color. As the angle of vision is reduced, so is the apparent separation between the strokes of color.*
The lines of color tend to blend in with those beside them, creating an optical sensation of the color of things. Stand about thirteen feet from the drawing (place the open book on a chair) and you will see how successful the experiment carrried out by this artist has been.

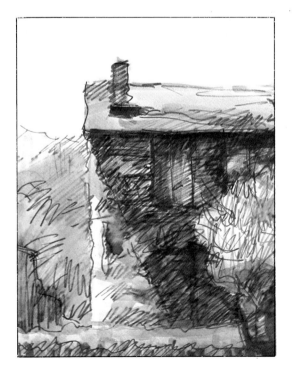

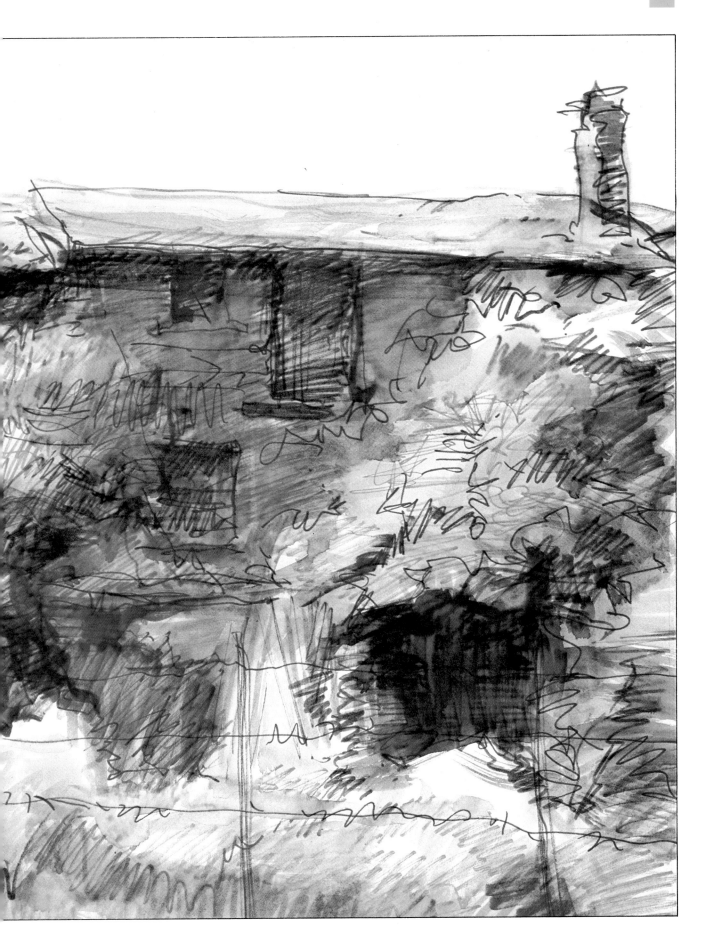

Marker pens and ink washes

We will continue with the mixed-media technique that combines ink wash and marker pens, but this time we will give a more important role to the markers. Again, following a demonstration by Miguel Ferrón, we invite you to work through an exercise that we hope will help you successfully complete a further stage in your development as an artist.

Our artist has set aside for a while his extreme originality and has returned to a more traditional approach.

As you are now familiar with the technique of hatched strokes of varying density, you will appreciate how Ferrón is capable of using marker pens in the traditional way. Even here, he does not abandon his spontaneous and decisive style, continuing his search for an "impression" rather than a concrete definition of form.

We stress the fact that by now you must have become familiar with the techniques. This being the case, we will not bore you with endless repetition. On this occasion, perhaps you will excuse us for using relatively few words to describe the exercise.

In short, the objective is to do the same as in the previous exercises: To make an initial sketch, to cover the main areas with ink wash, then to build up the form and color using felt tip pens, applied in just the right direction, intensity, and shade required in each case. So get ready to do the next exercise, guided by the photographs of Miguel Ferrón at work on the picture that serves as your example.

Two examples from a master of the medium

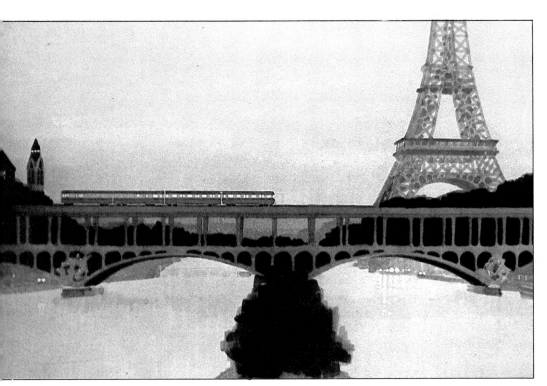

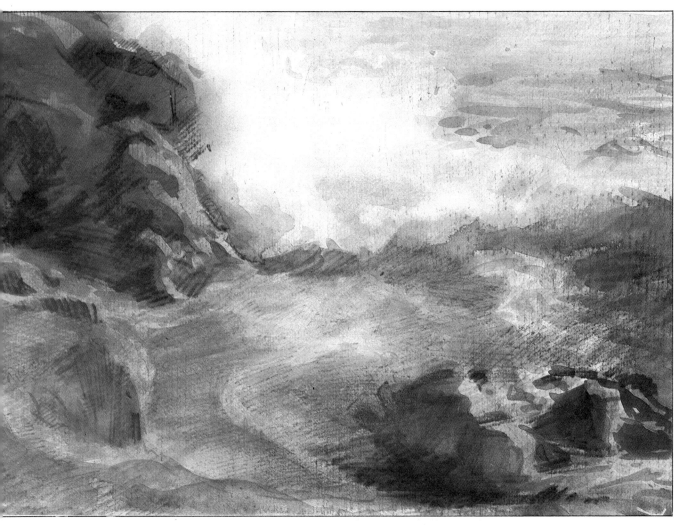

Left. *"View of Paris." Illustration created entirely with marker pens.*

Below. *"Breaker." Painting by Miguel Ferrón using watercolor wash and marker pens on a sheet of mat Schoeller watercolor paper, 12 × 16 in. (30 × 40 cm). When it was finished, the picture was given one last wash over its entire surface (with tap water), thereby giving it an ethereal quality. Obviously, to blend the watercolor wash with the marker strokes, it is necessary to use markers that hold water-soluble ink.*

Introducing the materials and the subject

On the right is a photograph of the "fishermen's harbor" in Barcelona that Ferrón is about to paint for you. As you can see, cool tones predominate over warm ones. The artist thought the cool values were excessively dominant and, in the final stages of the picture, chose to exaggerate the presence of warmer tones to achieve a better balance of chromatic contrasts.

Ferrón produced this painting on a sheet of mat Schoeller watercolor paper, 19½ × 22 in. (50 × 56 cm). The inks are made by Schminke and the markers are from Schwan-Stabilayout.

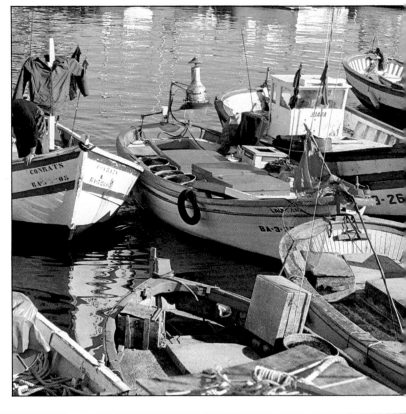

Below. Color chart showing the four inks used: Black, sepia, ultramarine, and cerulean blue.
Below, right. Color chart showing the eight marker pens used: Black, warm gray, ultramarine blue, sky blue, burnt sienna, scarlet red, raw sienna, and ochre.

Outline sketch and first washes

Appropriately for a subject in which blues are dominant, the outline sketch (as demonstrated here by Miguel Ferrón) is drawn with a blue water-soluble pencil or color-stick. You already know the reason for this: To establish the basic forms and layout of the picture; and, secondly, because the strokes dissolve when the first washes are applied and do not stand out too clearly in the finished work.

Left. Sketch of the subject using a water-soluble pencil or color-stick. Notice that Ferrón paid more attention to the real forms (the ones above the water level) than to the reflections. The reflections will come into their own when the first wash is applied.

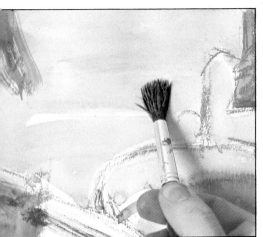

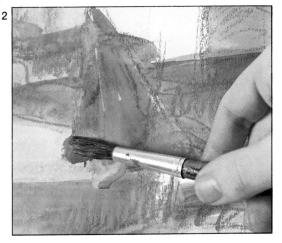

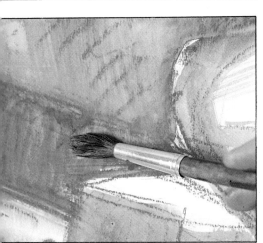

Left. Close-ups of the application of the first washes. The strokes of the water-soluble pencils have dissolved beneath the wash to provide the blues, even the more uniform pale blue area (1). The warmer tones (red and yellow) have been produced by marker pen strokes that have been diluted and immediately spread across the paper with a brush heavily loaded with water (2). As you see in close-up number 3, although the strokes of the sketch have been diluted, they have not disappeared altogether; this is not absolutely necessary. The blues that have a tendency toward violet (4) are blended with minute quantities of red ink from the marker pen, diluted in plenty of clean water.

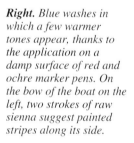

Using the marker pen

On the next two pages you can follow the first strokes of the marker pen applied by Miguel Ferrón on top of the earlier washes. From this point on, the different colored strokes stand out boldly, being applied to a surface that is already dry, so that they do not dissolve into the background washes.

Right. Blue washes in which a few warmer tones appear, thanks to the application on a damp surface of red and ochre marker pens. On the bow of the boat on the left, two strokes of raw sienna suggest painted stripes along its side.

Right. The scarlet marker pen is shown working on two areas of the picture. You can see here the bold, spontaneous style, so typical of Miguel Ferrón, that we described at the beginning of this section. If these strokes had been produced with draftsman-like or premeditated precision, the picture would undoubtedly lose all its impact and charm. Although they are spontaneous strokes, they still follow the direction best suited to the forms they represent and of the shadows and reflections they help to build up.

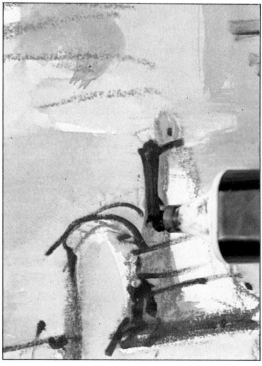

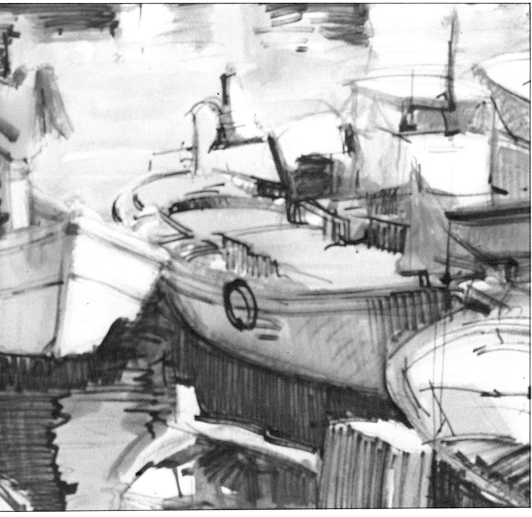

Left. The picture after the reflections and shaded areas have been reinforced using the scarlet marker pen. Notice that the strokes are almost parallel and that most of them are vertical.

Left. Close-ups showing the gray and ultramarine markers at work. Notice how the water has been treated: Parallel strokes have been added to the background tone using the sky blue marker, not covering it totally, but allowing it to "breathe" between the horizontal lines, suggesting the gently undulating surface of the water.

43

The finishing touches

When you look at the photographs on the last two pages of this step-by-step exercise, it is clear that Ferrón has applied his final touches with two aims in mind: To establish definitive contrasts between the different planes and, as mentioned previously on page 40, to strengthen the presence of warm tones as a balance against the predominance of cool (blue) colors.

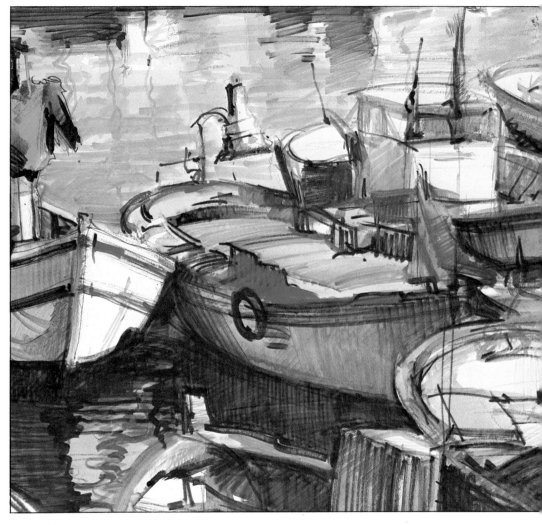

Near Right. The finished picture. Notice how important the ochres, siennas, and scarlets are in the lower half of the picture. The impact of these colors distracts the eye and prevents them from becoming lost amidst so much blue.

Far Right. Close-ups in which the work of the ochre marker pen can be seen in specific areas of the picture. When super-imposed on top of the blue it produces a green-ish tone and, by contrast-ing with the surrounding blues, it projects the wooden post in the fore-ground toward the viewer.

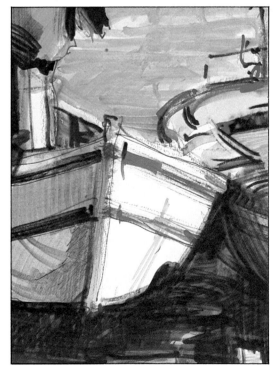

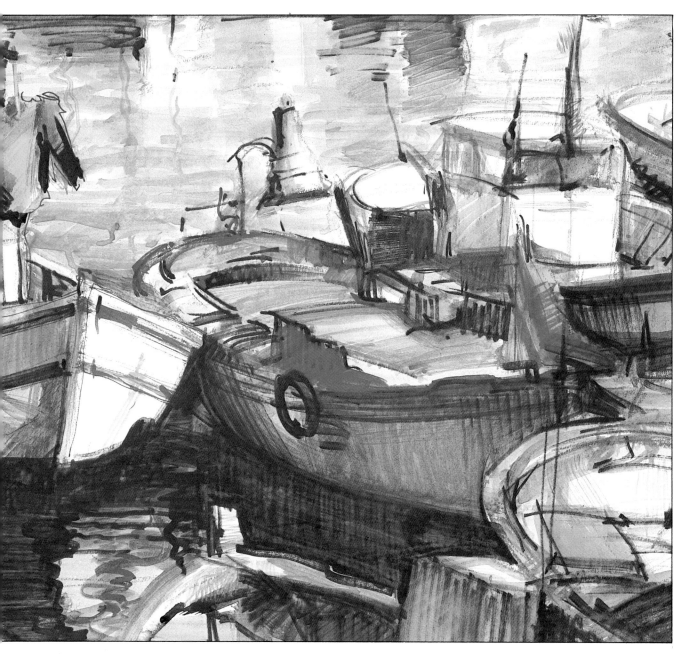

Above. *Here is the picture by Miguel Ferrón that we invite you to copy. It has been reproduced at a third of its original size which, as we said earlier, is 19 ½ × 22 in.(50 × 56 cm).*

Left. *Close-up in which you can see the uninhibited way in which our artist has recreated the water, reveling in the play of horizontal and irregular strokes.*

Watercolor and pens on canvas board

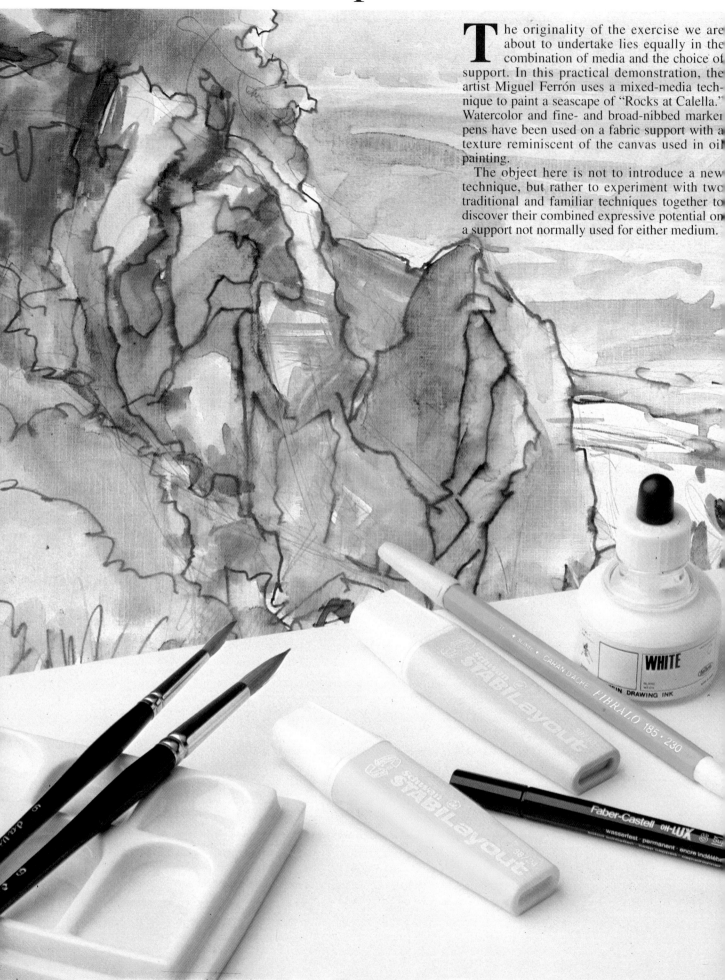

The originality of the exercise we are about to undertake lies equally in the combination of media and the choice of support. In this practical demonstration, the artist Miguel Ferrón uses a mixed-media technique to paint a seascape of "Rocks at Calella." Watercolor and fine- and broad-nibbed marker pens have been used on a fabric support with a texture reminiscent of the canvas used in oil painting.

The object here is not to introduce a new technique, but rather to experiment with two traditional and familiar techniques together to discover their combined expressive potential on a support not normally used for either medium.

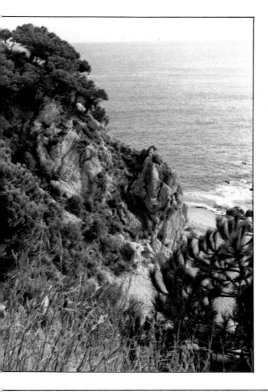

The initial sketch

When you use a fabric support, remember that it is not a surface that allows you to erase things easily. So make your sketch with a very soft pencil that leaves a mark without your pressing too hard. Miguel Ferrón's outline sketch (above) locates the main forms with faint lines drawn with a 4B lead pencil, so that if he must make corrections, he has only to brush the surface of the paper.

As you can see (left), the first pencil sketch has been reinforced with a fine, non-waterproof marker, but not with the intention of producing the kind of classic pen drawing that then will be colored. The outline will immediately dissolve in contact with the water, which will blend a little with the color. However, this outline will establish, at this early stage, the separation or dividing lines between the different watercolor washes.

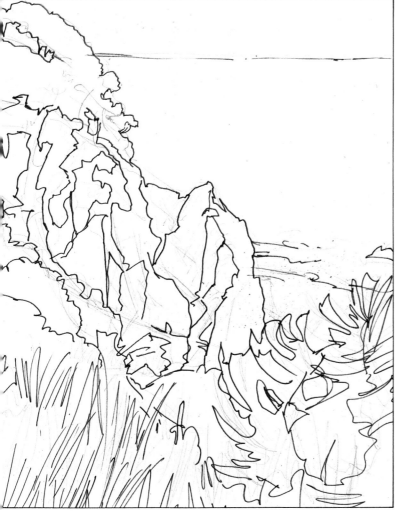

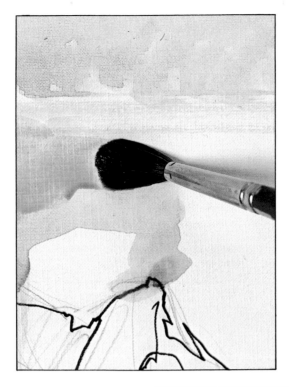

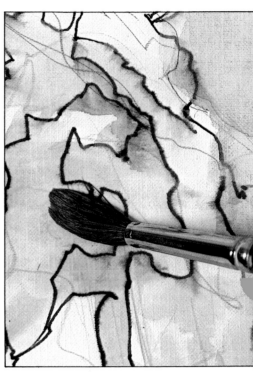

Right. Two close-ups showing the first washes being applied to the outline sketch. Look at how the water affects the black lines, which lose their sharpness and begin to blend with the recently applied color.

The first strokes

Using a limited palette (yellow ochre and ultramarine blue), the first strokes have been applied with the clear intention of establishing areas of color and dissolving the excessively complicated outlines of the base drawing. The ink of this sketch has blended with the washes creating bluish and violet shades that make an effective contribution to the tones of the watercolor background.

While working on these first strokes, Miguel Ferrón has obviously respected the traditions of the watercolor medium: Pure, clean colors, perfect transparency, and so on. Of course, one must take into account that the canvas board does not have the absorbent quality of watercolor paper.

To compensate for this lack of absorbency, a logical solution is adopted: The amount of color on the brush is controlled by squeezing a little of it out before it is applied to the painting surface.

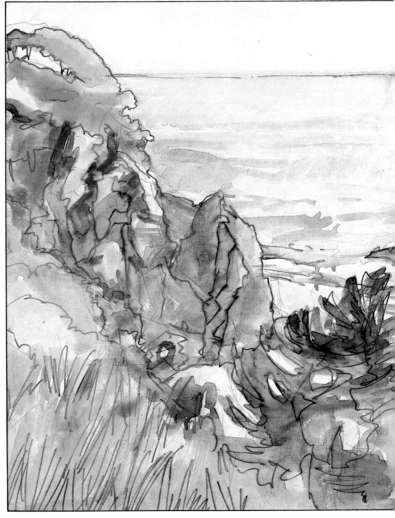

Right. Ferrón's picture after the first washes have been applied. The violet hues that appear on some of the rocks are the result of the black ink from the initial felt pen sketch blending with the blue washes.

Left. Close-ups of the
application of the darkest
washes on the foreground
trees and in the large
rock crevices.

The definitive background color

Miguel Ferrón continued to develop his
painting without abandoning the traditional
watercolorist's approach to enriching the color
scheme of his landscape. When you look at the
photograph on the left, you can see that the
artist could easily have left the picture just as it
appears here. He could have introduced a few
more nuances of tone and then have added the
work to his collection of watercolors.

However, because he had other ideas, the
watercolor part of this picture was left as you
see it, awaiting the **complementary** contribution
to be made by the felt tip pens. We have high-
lighted the word complementary to qualify the
contribution they actually make in this painting.
The intention of the artist was to give the pic-
ture a new dimension without making it a dif-
ferent painting.

Notice that the watercolor element of this
painting has served equally to establish the col-
oring of different areas of the picture and the
tonal contrasts responsible for creating the feel-
ing of depth.

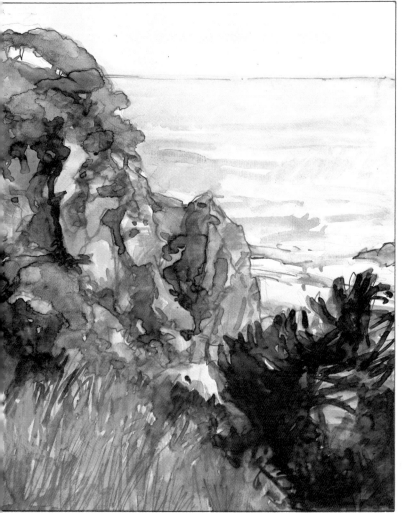

Left. Ferrón's work after
the watercolor stage has
been completed, before
applying the felt tip pen
strokes on top.

49

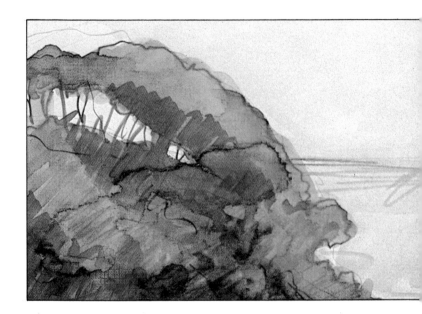

Clump of pine trees on top of the cliff, where a luminous blue-colored felt pen has been used. The sloping, parallel strokes follow the rhythm dictated by the tree trunks.

Central area of the rocks where red, blue, and yellow pen strokes have been applied. These strokes of pure color, which cannot be discerned from a distance, create a series of tones that give the painting character and a fine descriptive quality.

Rocky area nearest to the beach. The dark, vertical strokes lend solidity to the rocks and, at the same time, frame the illuminated strip of golden sand that, as a result, becomes a focal point of interest in the painting.

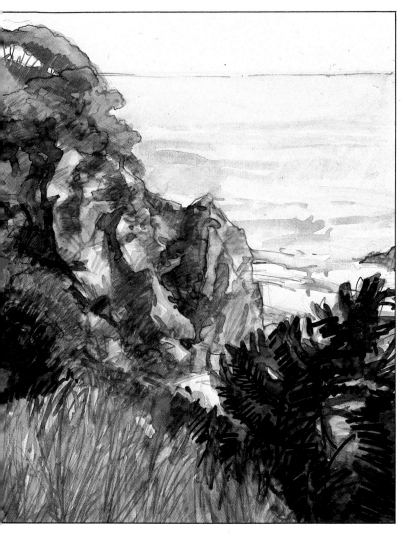

Applying the felt tip pens

Through this series of three close-up photographs, we show how Miguel Ferrón used felt tip pens to describe volume and form; far from making the various elements of the picture more indistinct, this process has sharpened them, given them greater solidity. Each stroke follows the direction most appropriate to the individual planes and masses of vegetation, contributing to the sense of volume.

The improved contrasts and richness of color help to emphasize form in the picture. The artist intensified the medium and dark tones of the foreground trees, drawing the eye to the little gap in the foliage through which you can see the beach. Notice how the diagonals in the composition lead to the beach area. It is a focal point of interest from which the eye of the viewer spreads outward, in a radial sense, across the surface of the painting.

Left. This is Ferrón's painting, already in a state that could be considered complete. However, the artist considered that it required a few final, vibrant touches.

Left. Two close-ups showing the fine felt tip pen at work adding further, individual strokes of new color, building up a remarkable richness of tone.

The pictorial values

Whether a painting is successful or not depends not on some aesthetic ideal (realism, expressionism, and so forth), but on pictorial qualities that are often difficult to define.

On this page, by means of three close-up photographs, we have referred to the pictorial values that emerge from an analysis of Ferrón's picture.

1. Luminosity of color, achieved through the controlled application of transparent layers, an excess of which would have spoiled the effect.

2. Quality of texture, brought about by the type of paper used. Notice in the close-up the areas where the artist deliberately applied only a faint layer of color. Where the marker has gone over the surface more than twice, the texture of the surface can no longer be seen, showing up instead the texture of the lightly colored areas by contrast.

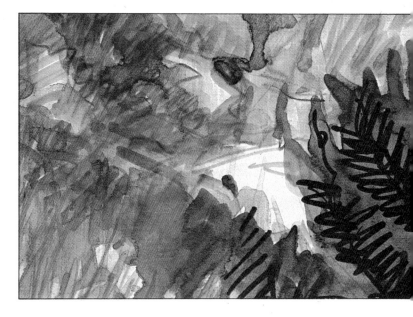

3. Richness of color, more intense in some areas than others. This is brought about, not by the background washes, but by the different-colored felt tip pens that, when applied layer by layer, taking care to preserve their transparency, have shown just what marker pens can do.

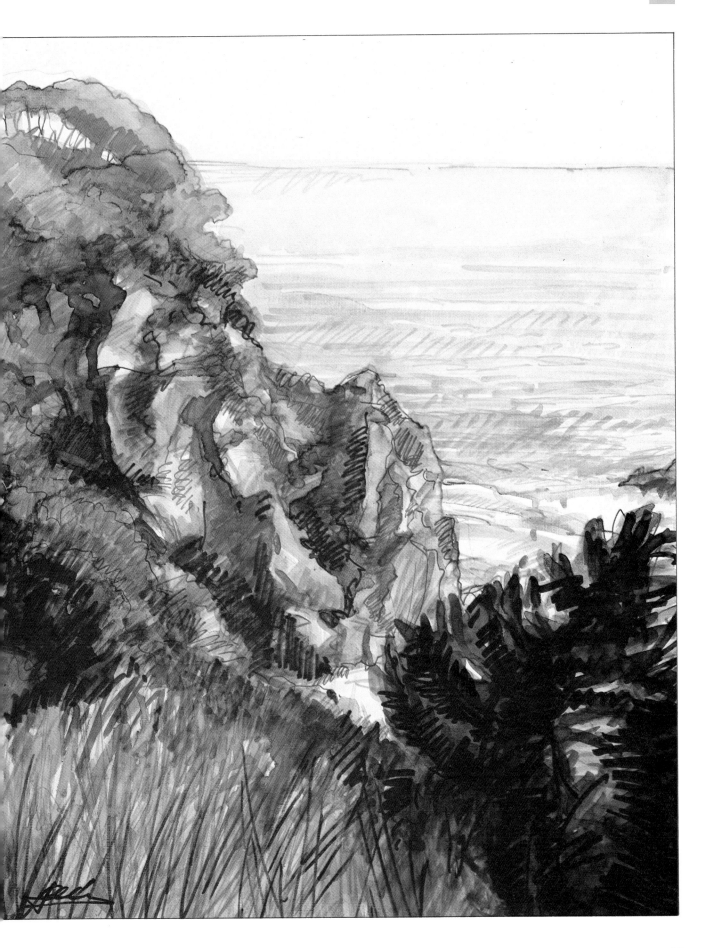

Watercolor. An abstract landscape

Some people who enjoy *looking* at works of art, as opposed to creating them, tend to be disdainful of any work whose main characteristic is simplicity and economy or harmony of style. They say things like: "A child could have done that" or, "Since when is the sky *that* color?" and again, "Anything is called painting these days; four blobs on a piece of paper and they tell you it's a landscape." Words like these suggest that the speaker has a very narrow idea of what a work of art should be; or perhaps it would be fairer to say that people like this have not reached an intuitive sense of what Art (with a capital "A") really is and what it means to our society.

In case you are not convinced, we have asked Ester Serra to show us, by means of a watercolor painting (a landscape, to be specific) that it is not easy to synthesize artistic expression, to achieve an abstract vision of the chromatic and formal values of any subject. It requires skill, and understanding abstraction should be considered an essential ingredient of true artistic creativity.

Three examples from masters of the medium

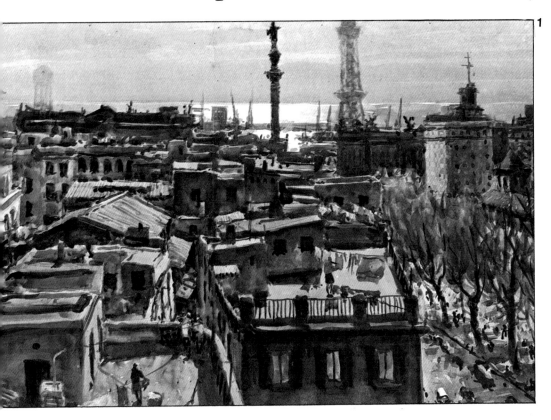

1 On this page we reproduced three watercolors that represent different levels of abstraction.

1. There is practically nothing linear in this watercolor by Ceferino Olivér. Light stands out above all from this vision of reality.

2. The ability to convey a great deal with few resources is a sign of a great master. The watercolorist Fresquet is able to go beyond material reality and paint pure atmosphere: It's hard to be more abstract than that!

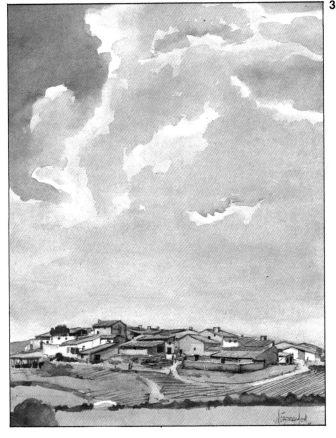

3. José M. Parramón gives us a lesson in his highly personal style on how to achieve synthesis and harmony. Take away the pen strokes and white areas from this landscape and there would be nothing left.

Preliminary studies

Looking at this scene, it is tempting to create from it a picture full of detail. However, the abundance of vertical planes and the strong contrasts created by the light inspired Ester Serra to consider an abstract vision of this subject, in terms of form and color. Because departing from detail to arrive at the essence of a subject is never a casual exercise, our artist made two preliminary studies: A monochrome drawing as a study of the basic structure and the contrasts between the various planes, and a watercolor study to try to achieve synthesis of color.

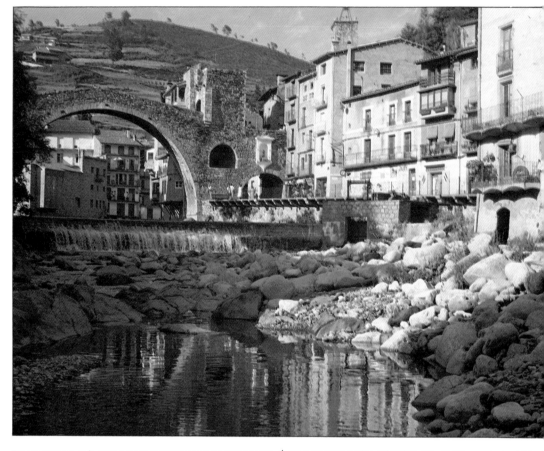

Right. These studies were produced by Ester Serra before she began the definitive version.
1. A magnificent study in which the basic forms have been described as simply as possible using marker pens and ink wash.
2. Close-up of the same study.
3. Watercolor study in which the artist worked out the main areas of cool and warm tones that constitute an abstraction from the real colors.
4. Close-up from the same study.

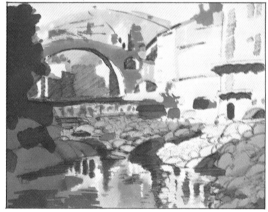

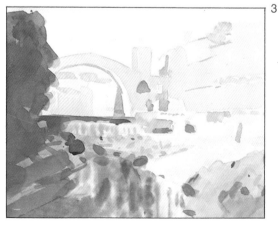

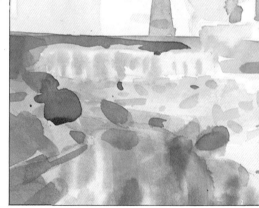

The outline drawing

On watercolor paper with a fine-grained texture, Ester Serra produced an initial sketch with a blue water-soluble pencil. Notice that, even at this stage, the objective is to reduce the drawing to the bare essentials, ignoring any unnecessary details—that is, anything that does not contribute to the fundamental structure of the subject. It is not by chance that a blue water-soluble pencil is used for the sketch. Blue being the predominant color of the subject, the fine lines and the soft tone applied in areas of shadow provide a good base color, once water is applied, and will not cause problems later. Apart from this, the pencil lines are water soluble, guaranteeing that the marks of the initial sketch will disappear once water color is applied on top.

Left. Four close-up photographs of Ester Serra's work show the first washes being applied, and the effect of the water-soluble pencil marks on the sienna wash, which takes on a richer tone. Merely by applying clean water, a background wash is created. On the next page, you will see how to make the most of this possibility.

The first washes

Using a lot of water and very little color, the artist blocked in the first washes. She used just two colors: Prussian blue and raw sienna. The blue wash contained hardly any color because, once applied on top of the water-soluble pencil lines, its color would be intensified. Although this is considered just the first stage of the painting process, note that the three main areas of tone have already been defined: Shadow (the blue areas), half-light (sienna), and sunlight, represented by the areas left white.

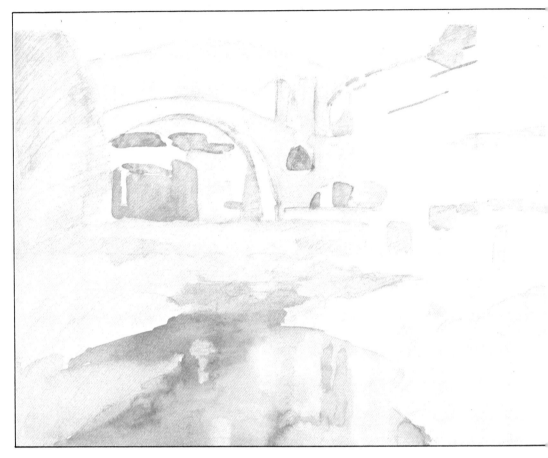

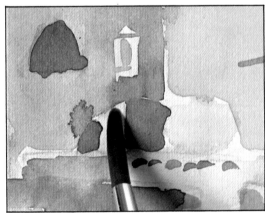

Right. These four close-ups demonstrate the process described on the next page, in which the artist accentuates contrasts through a two-color operation. The right hand pictures correspond to the stage just completed, in which the pencil markings are still visible, and the other two show the same areas of the painting after more color has been added.

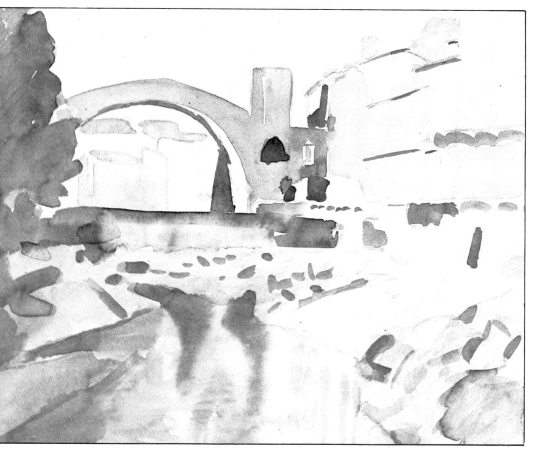

Emphasizing contrasts

The decision to include nothing but bare essentials led the artist to concentrate on tone and volume. She thought, quite rightly, that this would make the later job of introducing a more descriptive element much easier. If you turn back a couple of pages and look again at the first watercolor study the artist produced, you will see that she has returned to her point of departure, in which the most illuminated areas are not left white (as in the previous stage) but have taken on a shade of yellow ochre, giving them a more luminous quality.

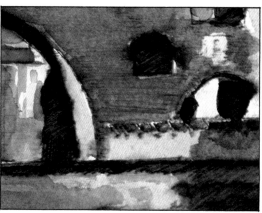

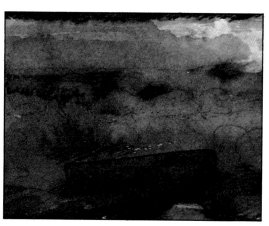

Left. From the stage just described, Ester Serra used the wet into wet technique to develop her painting, as you can see in these four photographs. In one of them you can see her soaking up color with a piece of absorbent paper towel.

Richness of color

Working wet into wet, Ester has enriched the color in each part of her painting, thinking always about the intention of every brushstroke. However, it is important to realize that in this landscape, which we have described as abstract, the brushstrokes enrich the color but do not actually describe form. You can see in the close-ups below, as well as in the finished picture, that these strokes of color are abstract forms located within previously drawn limits (either spreading beyond them or not quite covering them completely). Their only purpose is to create a series of visual effects or impressions of color that, seen as a whole, suggest what they represent in reality. What we have here is not *that* landscape; it is an image of it, an abstraction from what we actually see with our eyes.

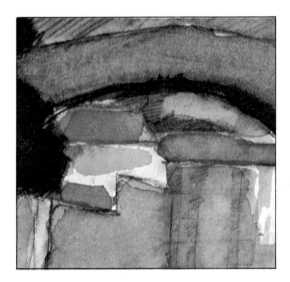

Right. Close-ups showing clearly the purely chromatic value of certain areas of color. They have been treated as abstract forms that, within the unique context of this painting, suggest the color of light on a wall or a roof . . . or (in the second close-up) mobile reflections and their relationship, in terms of color, with the objects that create them.

Watercolor painting. A seascape

In principle it must be assumed that every pictorial process is versatile. That process should be equally capable of expressing, in artistic terms, any subject: The human figure, landscape, seascape, still life, and abstract images. Generally, this is true. However, some media seem to have been invented with a certain subject in mind. This could be said in relation to pastels (considered by many to be the ideal medium for depicting the female nude) and something similar to watercolors, which seem to have been designed especially for painting seascapes. It is possible that this arises because the artist, without realizing it, associates the transparency of the medium with the transparency of water. By seascape we mean every kind of landscape in which water plays a prominent part: sea scenes, lake and river views, and so on.

If you paint with watercolors, however infrequently, the chances are that sooner or later you will find yourself painting a seascape.

So why not start right now? We invite you, by way of an introductory exercise, to follow the practical demonstration provided by Juan Sabater.

Two examples from masters of the medium

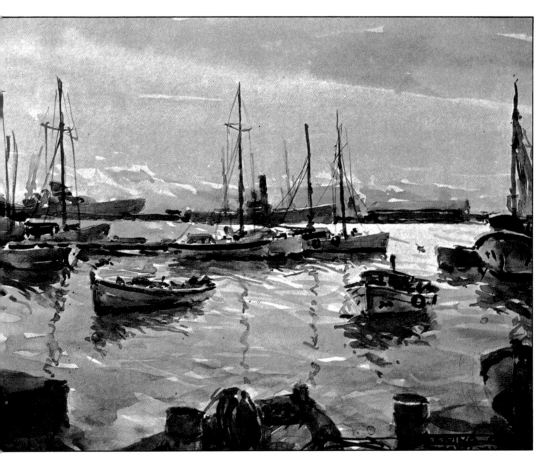

Study and admire these two seascapes. Though separated in time, both offer important lessons in the masterly exploitation of the transparency of watercolor.

Left. "Light (in Castellon)," painted by Ceferino Olivér in 1978.

Below. "St. Paul's Cathedral" by John Sell Cotman (1782–1842), one of the greatest English watercolorists of the 19th Century. In both examples, all the qualities of watercolor have been exploited in order to convey to perfection the transparency of water.

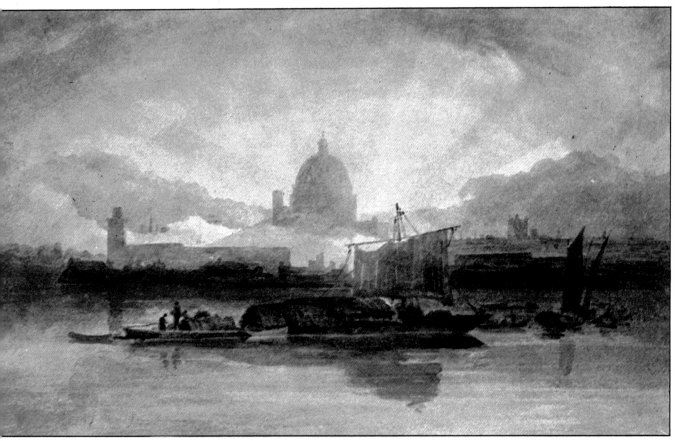

The color range

Sabater tends to use few colors in his work, although he does explore every possibility afforded by his limited palette. Watercolors, with their characteristic luminosity and transparency, are perfect for this style of painting. By mixing them on the palette, or by laying successive washes on the paper itself, working in dry or wet, our artist found that the four colors shown below were all he needed for his interpretation of the subject.

Range of four colors chosen by Sabater and the possibilities offered by different color mixes, by working wet into wet, or by going over dry areas of color.

Charcoal sketch

On a sheet of water-color paper, Sabater has drawn a charcoal sketch, using stronger lines than usual to distinguish the forms very clearly. Once he is satisfied that the sketch is accurate, he dusts the surface of the paper with a cloth so that only the faintest guidelines remain. They provide a reliable guide to the outline of each form for when he starts to apply color.

Two close-up photographs showing the faint guidelines of the charcoal sketch and the first application of the Prussian blue wash. These pictures correspond to stage 2, which is described on the next page.

The first wash

With masking fluid, Sabater has masked out the main areas to be left white (mainly on the boats), so that he can freely apply the first washes of color. The initial wash is a general layer of Prussian blue, deeper towards the fore-ground and on the boat near the back of the picture.

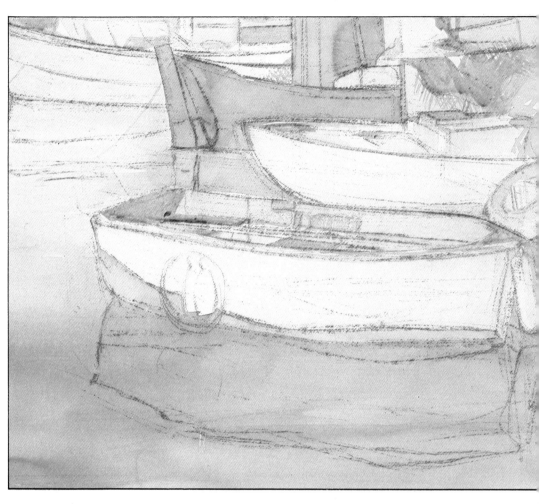

Building up color

Describing the various actions of the artist dur-ing the execution of a painting is very difficult, not only for him but also for anyone trying to translate his thoughts into the written word.

We will try to sum it up: After completing the previous stage, Sabater began to define the tones (especially the reds and blues) of the most important parts of the picture, either by filling these areas with color, or by containing them within surrounding areas of color. On top of the first blue wash, several new layers have been applied, adapting the initial color to indicate reflections in the water.

Where the reflections are, the colors of the boats have been added to the basic blue, creat-ing earthier, less pure tones.

These stages are shown in the close-up pho-tographs on this and the next page, where you can also see an overall view of the painting at the end of this stage of its development.

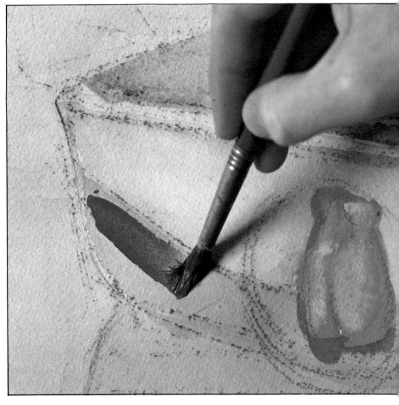

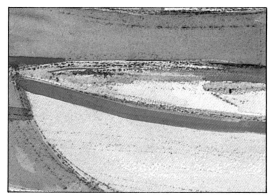

Outlining in red the upper edge of one of the boats. This is just to establish the color that will be built up at a later stage.

Thin layer of sepia applied beneath the boat in the foreground, indicating its reflection. This area has been applied with a large, flat brush on top of the blue background, which by now is almost dry.

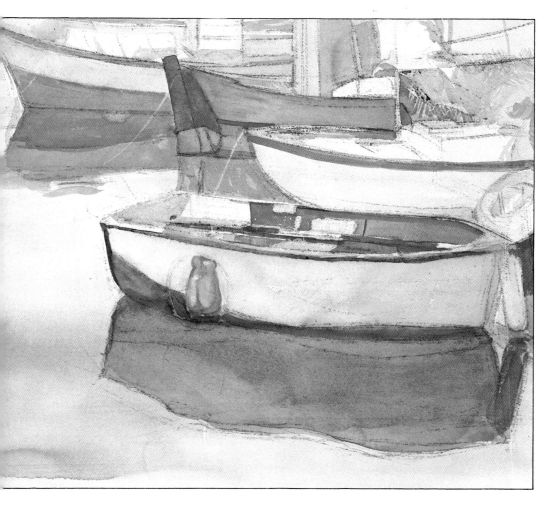

This picture shows the watercolor at the end of the stage we just described. Notice that the first layers of color are intended to define the basic colors of the boats and their reflections, and to locate and define the various forms. Now that everything is in its place and the main areas of color have been blocked in, it is time for the completion. Let's turn to the next page.

Completing the picture

Further layers of color have been added on top of the basic tone to emphasize the darker areas. Sabater, remembering the technique of the great masters of the baroque era, has worked patiently and subtly, altering shades and tonal values with successive applications of delicate color. This enabled him to create nuances of tone within each of these dark areas, so that when seen as a whole, they lend a vibrancy to the painting that areas of uniform color would not achieve.

At this stage, the artist has removed, using an eraser, the areas protected by masking fluid. Sabater subsequently ran a delicate wash over these areas to make them less harsh. If you compare the finished work with the last photograph on the previous page, you will see that the colors of the objects themselves have been intensified and the reflections have been built up with brushstrokes of cool color, taking care not to destroy the luminosity of the few warm patches.

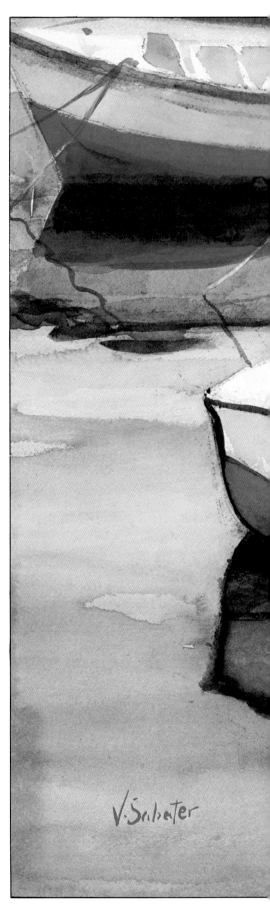

Close-up showing the flat brush applying a layer of deep carmine on top of the previous tone in one of the reflections.

Using an eraser, remove the sticky gum formed by the masking fluid you applied earlier to preserve the whiteness of certain areas from the successive color washes.

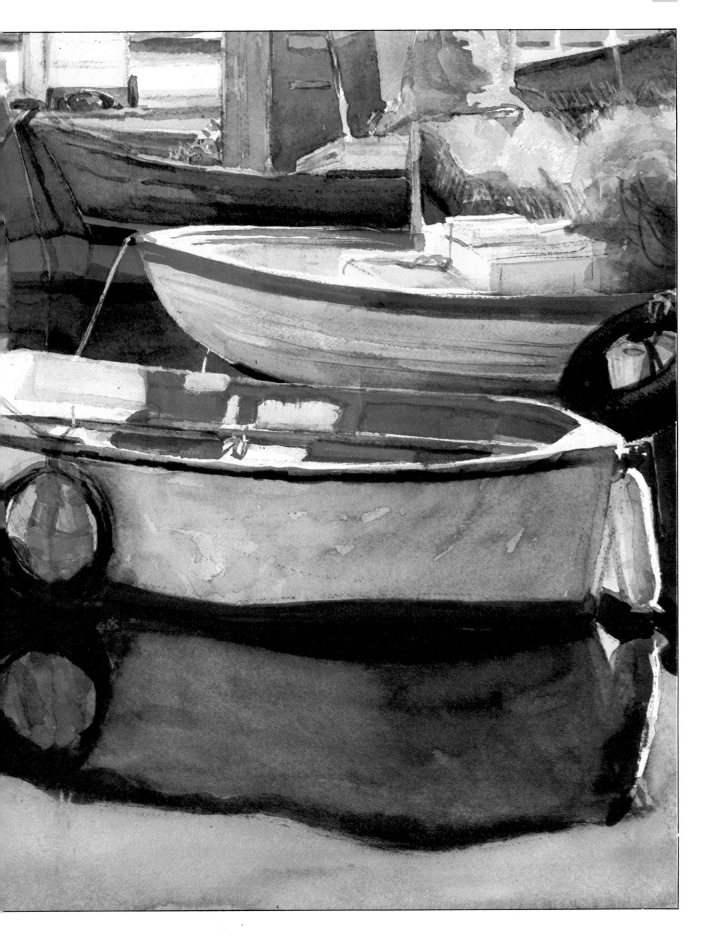

Watercolor painting. A village scene

This time, our artist is going to paint a watercolor sketch depicting a village basking in the early evening sun (a low sun, in other words), in an atmosphere inundated with warmth and light.

In the background of this page is a pencil sketch of our subject, through which we will introduce to you a new technique that combines two traditional methods of applying watercolor: Wet into wet and wet onto dry.

As we keep saying, you are free to copy the example we offer; however, you should feel equally at liberty to choose a different subject, as long as you follow the method described by our guest artist (Miguel Ferrón, in this instance), because it is this aspect of the exercise that we hope will teach you something. In other words, whether you paint the same houses as Ferrón, or some other houses, is of no importance. The important thing, if you want to improve your technical skills, is that you try to paint your own subject in the same way your teacher (Ferrón) paints his.

Four examples from masters of the medium

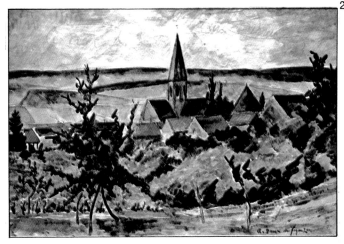

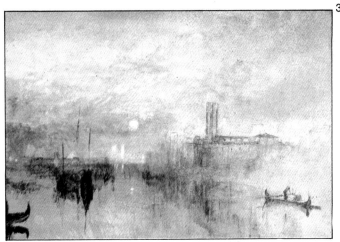

1. *"A garden in Shoreham" by Samuel Palmer. An example of watercolor applied quite thickly, with touches of white, silver, and gold.*

2. *"Fencherolles in Autumn" by André Dunoyer de Segonzac. Watercolor on a dry surface, with no transparent washes.*

3. *"Venice" by J.M.W. Turner. The great 18th Century watercolorist demonstrates in this work the capacity of watercolor to produce luminous, transparent effects.*

4. *"Marsh" by Aida Corina. This is a modern example of the wet into wet technique, in which blended tones are used in combination with detailed work added when the paint is dry.*

Introducing the subject

On the right is a photograph of the subject Ferrón is going to paint, taken from the spot where he set up his easel. It is a straightforward subject, with two clearly defined areas (a foreground represented by the tree trunk and a background consisting of the houses). These do not present problems of perspective or any great color contrasts. It is easy to see that the feeling of depth depends, principally, on the proportional relationship between the size of the tree and that of the houses; in other words, it is a question of scale.

In the course of this exercise, our artist hopes to show you not just how to paint a landscape in watercolors, but also how to explore the possibility of a mixed technique. This mixed technique calls for combining brushstrokes applied to damp paper, to blend color, with others applied when the surface is dry to sharpen outlines and heighten contrasts. Although you are undoubtedly familiar through your own experience with the effects produced by applying brushstrokes to either a wet or a dry surface, we have finished off this page with an illustration showing the differences between the two results. Our examples from the masters on the previous page also show these variations through very different types of work: Some in which the essence of the painting lies in the fluid transparency of color and others in which watercolor was applied to a surface that was practically dry.

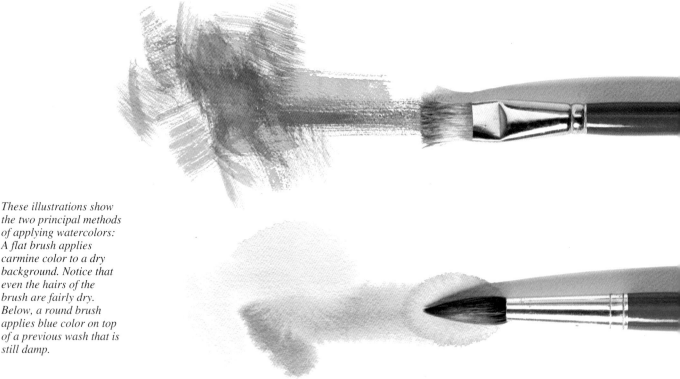

These illustrations show the two principal methods of applying watercolors: A flat brush applies carmine color to a dry background. Notice that even the hairs of the brush are fairly dry. Below, a round brush applies blue color on top of a previous wash that is still damp.

Step 1. Outline sketch and first washes

Ferrón has made an outline sketch of the subject using a cyan blue water-soluble crayon. By using a water-soluble crayon, you can totally dissolve the initial drawing beneath the watercolor wash, if you so choose. The blue tone will also provide a general background color that, in this instance, helps to balance the warm, sunlit tones. After drawing the sketch, Ferrón damp-

ened the whole surface of the paper to prepare it for the wet into wet process.

In the photographs on this page, you can see how the first transparent washes affect the lines of the initial sketch. Color has been added to the wash only in the areas corresponding to the walls of the houses. In the sky, the tree, and on the ground, the only color has come from traces of the water-soluble crayon.

Step 2. Working wet into wet

This page shows all the stages in which the artist has worked on a damp surface. He has used warm colors, knowing that the cyan blue of the initial sketch would dissolve into the first wash, introducing a cool tone in the shaded areas on the walls and also the left side of the foreground tree, where the ochres have taken on a greenish tinge.

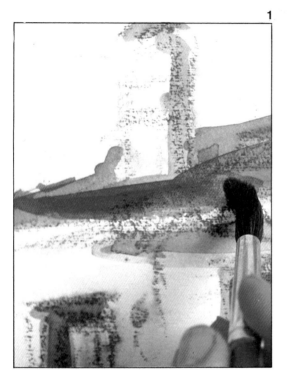

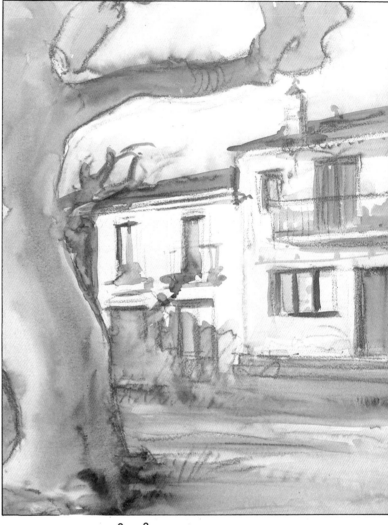

In the overall view as well as in the three close-ups on this page, you can see the blending of colors, characteristic of watercolor applied to a damp surface with a well-loaded brush.

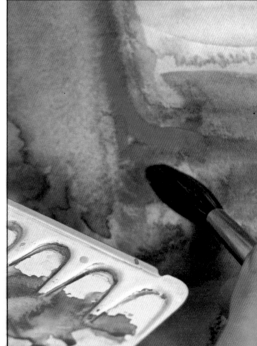

Close-ups.
1. A section of the roof.
2. Front door of the house on the left.
3. Base of the tree, with warm colors being added.

Working on top of the initial washes shown on the previous page, Ferrón has continued, still on a damp surface, to intensify the warm tones (see the three close-up pictures on this page) and to blur the lines of the original sketch. At the bottom left-hand side of this page you can see this process being carried out on one of the branches of the tree: A brush loaded only with water dissolves the water-soluble pencil lines, blending them into the adjacent warm tones.

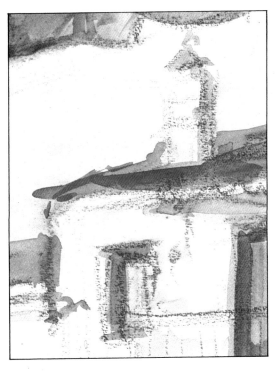

Notice that until now, the artist has kept the color transparent, even in the darkest areas. He has achieved this by building up the overall tone very gradually, using faint washes of color mixed on the palette and tested on a piece of scrap paper, to avoid applying too intense a tone to the painting itself. This precaution (having a scrap of paper on hand for testing tonal intensity) is strongly recommended for beginners in watercolor painting.

Step 3.
Working on a dry surface.
Completing the picture

The painting lacks strength at this point, especially in the appearance of the large tree in the foreground. This must be strong partly because of the dominant position it occupies in the painting as a whole, and also because an effective contrast between the tree and the background of the picture is essential if a sense of depth is to be created.

But let's leave the tree until the end. Once the paper is dry, start strengthening the tones and lines of the buildings such as those that describe the shape of the chimney or the balcony rail on the main building (see the first two illustrations on this page). Strengthen your picture wherever you feel it needs definition, whether of form or color. But don't think about it too much—just follow your instinct and work on each area, using the "wet on dry" method.

When you are satisfied with the background of your painting, move on to the large tree; now you will be able to judge the most appropriate tone for the foreground.

Ferrón has intensified the shaded area of the enormous trunk considerably, while leaving the illuminated side practically untouched. The brushstrokes applied to a dry surface form an uneven contrast that enriches and adds texture to the initial appearance of the painting. And this has been achieved without sacrificing any of the spontaneity so characteristic of Miguel Ferrón's work. His parting comments are, "This watercolor, even in its completed state, should be thought of as a color study and not as the definitive work that I will perhaps go on to produce in my studio, using this as a starting point."

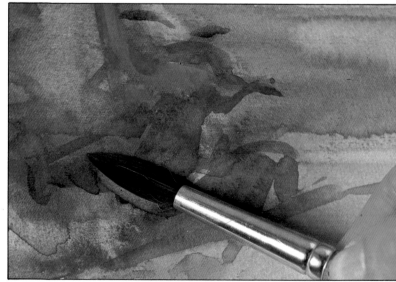

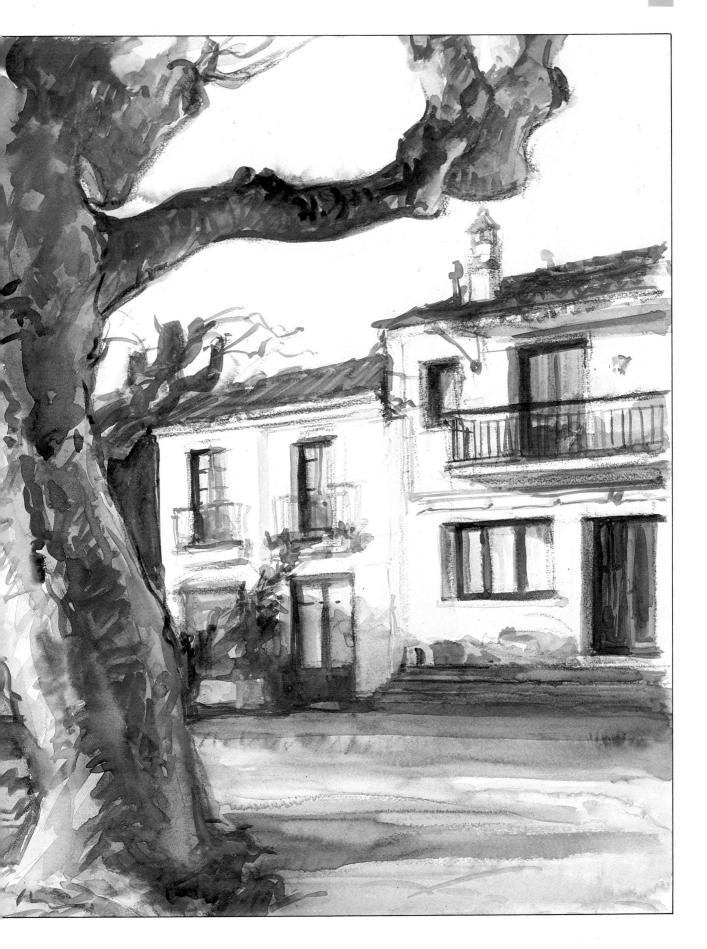

I t is a widely accepted view among those who teach drawing and painting that floral themes are particularly difficult for beginners. The reason is easy to understand: The novice gets carried away with the form of each flower at the expense of its importance as part of an overall chromatic design. However (for precisely the reason just stated), painting flowers under the guidance of an expert can be an extremely instructive experience; it forces the beginner to suggest form through color, moving him or her away from the natural tendency to grind out a painstaking study of the basic forms, and then simply to color them in afterwards.

Get ready, then, to paint a floral theme in watercolors under the guidance of Juan Sabater, as we describe the steps he takes in the creation of his picture. Once again, we stress that you can either use our subject or, if you feel like being more adventurous, compose your own floral arrangement.

Three examples from masters of the medium

The series of examples we have chosen show three completely different ways to perceive and interpret a floral theme.

Left. For Ester Serra, the floral theme is just the inspiration for creating an abstract, expressionist composition and, also, for experimenting with the medium and discovering new qualities and textures. Form, color, and texture are the three pillars supporting any work of art. And each of them has an aesthetic value of its own.

Above. This study by Gerard van Spaendock is very analytical in character; it is designed solely to explain the structure of a particular flower.

Left. "Iris and poppies" by Emil Nolde, the German expressionist painter. In this watercolor, he shows us how effective color can be when you possess the necessary skill to apply it with simplicity and precision.

Introducing the subject and preparing the paper

The floral theme that Sabater intends to interpret in watercolor is, as you can see, extraordinarily colorful. This leads us to consider the various technical resources we may need to call upon in the course of producing this painting.

Bearing in mind that many separate applications of color could have had a damaging effect on the paper (a 10 oz, medium-textured Arches watercolor paper), Sabater decided to prepare it in advance, soaking it in water to stretch the fibers. He then attached it firmly it to a piece of plywood with strips of tape, applied with the aid of a sponge. The photograph at the bottom of the page illustrates this process.

Sabater tells us that, normally, he would just fasten the paper down with a few clips. But, on this occasion, he has resorted to the process of stretching the paper because he wants to work primarily using the wet into wet technique—not that he wishes to exclude the possibility of painting the odd bit of detail on a dry surface.

The interest of this exercise as part of the learning process lies in the variety it offers: Variety of color, of form (the different flowers) and, as a consequence of this, variety in the method of representing the different parts of the picture. Nonetheless, this should not cause us to lose the sense of harmony and unity. From the moment you set up the composition of your floral theme, to the moment you decide how you are going to interpret it in a watercolor painting, you should bear in mind that your picture must be a harmonious whole in which each element is subordinate to the overall vision or idea.

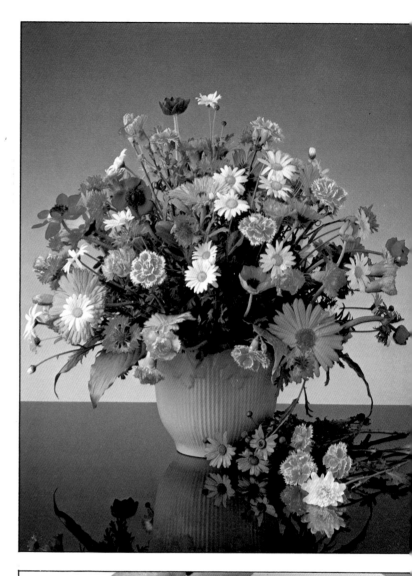

Above, right.
Photograph showing the floral arrangement Sabater used as a model for the watercolor illustrated on the next few pages.

Right. *Once the paper has been soaked and drained, it is fixed to a wooden board using four strips of tape.*

Step 1. Outline sketch and applying the mask

A faint outline sketch drawn with a lead pencil has located the principal areas occupied by the flowers and the vase and, with a few light strokes, the main leaves, and stems. After this, Sabater applied masking fluid to the areas that are to remain white (this is a technique he uses rarely); these are, in fact, the areas that correspond to the white flowers.

Left. Sketch of the subject drawn with a grade 2B lead pencil.

Below. Applying the masking fluid to areas that are to remain white, using a round No. 8 brush. Notice the deliberate unevenness of the brushstrokes, which gives the forms character rather than a precise outline.

Note, in the photograph on the right, that the whited out areas have been established with hasty, irregular brushstrokes. As a result when the mask is removed later, the contours are not too defined. In Sabater's words, "The idea is not to make a perfect drawing of each individual flower, but to depict them in a way that conveys the spontaneity of the subject."

The artist was aware that getting bogged down by trivia at the beginning of a painting could cause him to lose sight of the overall intention; there would be plenty of time later on to concentrate on the character of each particular flower.

It is possible that this is the first time you have needed to use masking fluid. If this is the case, then consult your regular supplier of art materials on what to buy and how to apply it.

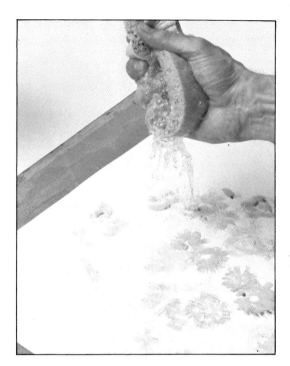

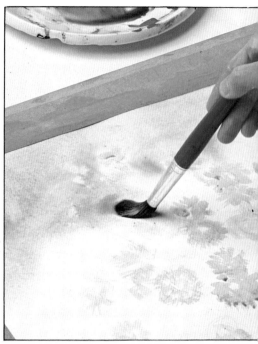

Right. *The paper is made damp for a second time. You can see the traces of masking fluid.*

Step 2
The first washes

Working with a wooden board (on a table), Sabater has dampened the paper again, squeezing water from a sponge and spreading it over the surface. The background colors have been indicated with cobalt blue and burnt umber, and the colors of the vase with vermilion and deep yellow. Each delicate wash has been gently spread across the damp paper. Sabater says, "If a generous combination of pigment and water are applied, you can almost always create an effective background, transparent and rich in color, even if, along the way, you decide that it needs to be modified."

As you will see in the photograph on the right, for Sabater there is no better palette than a good-sized, white china plate. When you have to cover large areas, or need to mix a generous wash, you will need a "palette" that allows you to mix up considerable quantities of color.

Through the process of adding and removing color, you will finally achieve the shade and tonal intensity you require in your painting. After this stage, it is a good idea to allow your watercolor to absorb a little of the excess water that will probably be lying on its surface. It is better to start the next step with the paper a little drier, although it must be moist enough to allow the color to run to some extent.

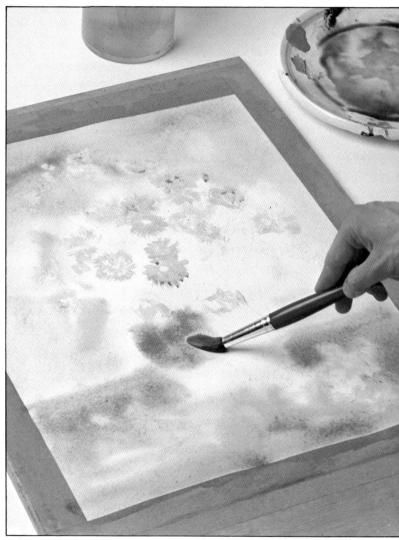

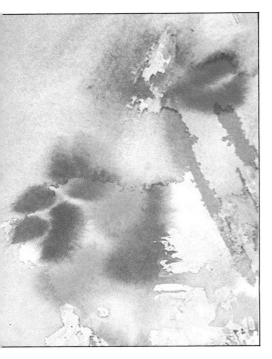

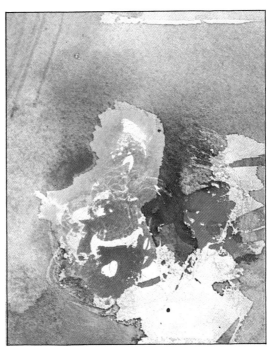

Left. Close-ups showing how the color runs to a greater or lesser extent in different parts of the pic- ture depending on the dampness of adjacent areas. Notice the "tex- tured" quality created by the masked-out whites.

Step 3
Enriching the color

When the paper has dried enough so that any new color added does not run as much, it is time to start building up the color.

Look at what Sabater has done: First, he removed the sticky mask protecting the white areas. This revealed light patches or shapes that served as a guide for situating the blobs of color that (during the next and final stage) will become individual flowers. In the two close-up illustrations at the top of the page, you can see the descriptive quality these blobs of color can take on, with the color running to a greater or lesser extent according to how damp the paper is.

It doesn't matter at all that some patches of color are more defined than others. The impor- tant thing is that they represent the basic shapes of the flowers and provide an indication of their real color.

Notice that Sabater has only blocked in the reds, yellows, and violets. You can see at once that he has saved the cool colors for the final stage, by which time the drier paper will allow him to use a different technique.

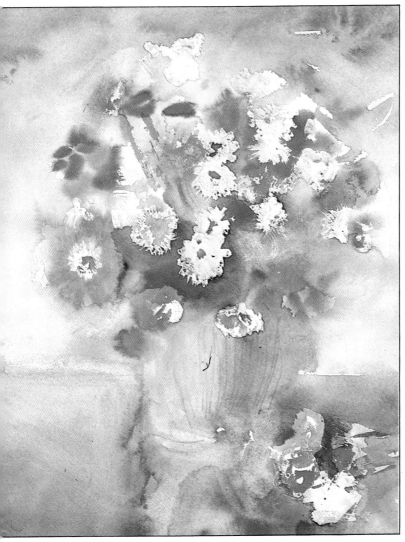

Left. Juan Sabater's work at the end of Step 3.

83

Step 4
Completing the painting. Working on a dry surface

The moment has arrived to establish the approximate contours of each flower. For this task Sabater has reserved the cooler tones, much darker and less transparent than the luminous reds and yellows of the flowers themselves. These later brushstrokes have been applied to a dry, or almost dry, surface, allowing the artist to exercise greater control in defining the form and limit of each flower. This can be seen in the last two close-ups. The white flowers are surrounded by greens and blues (try not to get paint in these areas now that the mask has been removed). Delicate, slightly more transparent strokes have been used on the stems and leaves that complete this dazzling display. Incidentally, Sabater has described the terracotta vase only superficially, so as not to create two focal points of interest within the one painting.

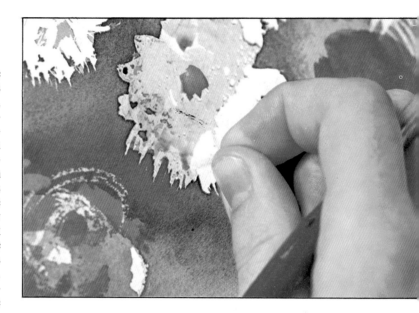

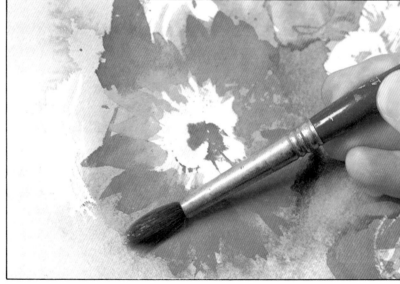

Above. *Close-up showing the artist's hand removing the masking fluid from the white areas of the painting.*

Right and below. *Three illustrations showing the brush working on a dry surface. In the first picture (right) the brushstrokes suggest petal*

formations and, in the second, darker tones outline and emphasize by contrast the shape of another flower. In the third picture (below), you can see that the flowers on the table actually consist of a few impressionistic brushstrokes and some preserved white areas.

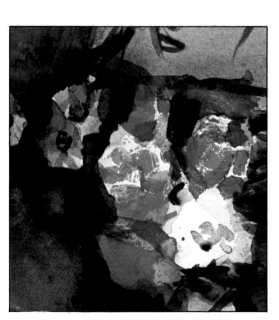

Watercolor. Fishing port

We return once again to a watery theme, to reaffirm what we learned a little while ago through Sabater's seascape: That watercolor, because of the transparency of its washes, is a process that seems to have been invented for painting vast expanses of water. This time we invite you to use watercolor to explore the transparency of color in the tranquil waters of a fishing port. The harbor or port is a particularly interesting subject for learning about the character of water: How its still surface acts as a mirror to the shapes of the moored vessels; how light reflects off the smooth, liquid surface onto the hulls of the boats; how the reflection of water gently rippling in the breeze variegates the tone and color of shadows. All of these details contribute to the atmosphere of a painting and seem to demand the use of transparent color. Miguel Ferrón, in this step-by-step demonstration, invites you to create a study in color of a harbor theme, in which, irrespective of how meticulous an approach you wish to adopt, all the brushstrokes must retain the characteristic transparency of watercolors, to recreate, visually, the transparency of water.

Two examples from masters of the medium

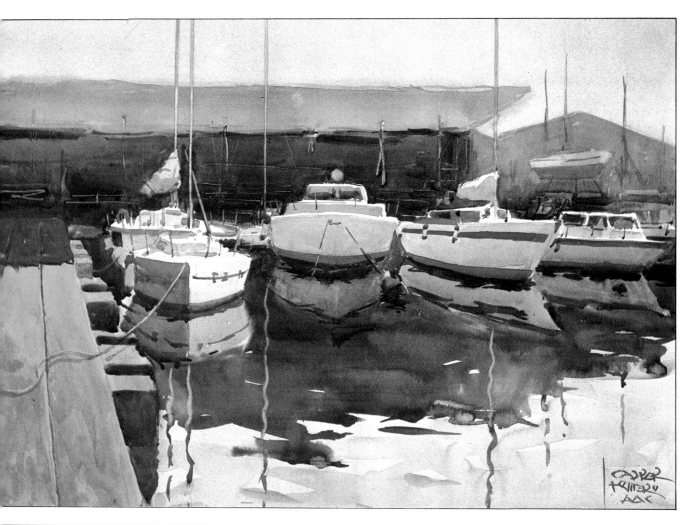

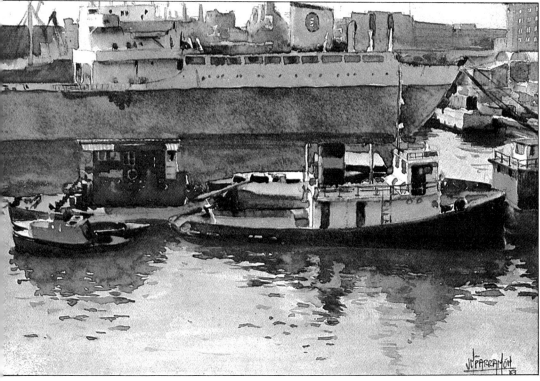

Above. Harbor theme by Gaspar Romero. Particularly remarkable is the simplicity with which the artist has created the reflections, those corresponding to the hulls of the boats being much lighter in color. The feeling of the mobility of the water is emphasized in the undulating lines of the masts in reflection.

Left. In this watercolor by Parramón, we can admire the extraordinary transparency and luminous quality of the greens and blues. In this painting there are few totally pure colors, and yet the tones remain clear and translucent.

Step 1. Composition and outline drawing

When you contemplate a landscape or a seascape, remember that it is not necessary to paint everything you see before you. On the contrary, you must get into the habit of choosing different elements that demand to be painted. It's a question of knowing how to frame a scene, as if you were trying to take a good photograph.

Ferrón, studying the harbor in the photograph either mentally or with the help of a window cut into a piece of cardboard, chose for his painting the part of the subject contained within the red frame. Once he made this decision, he outlined the most important elements of the composition using barely visible pencil strokes. Then, with a faint, ultramarine wash (water with a hint of color), he filled in these outlines, indicating the solid masses that appear in the painting.

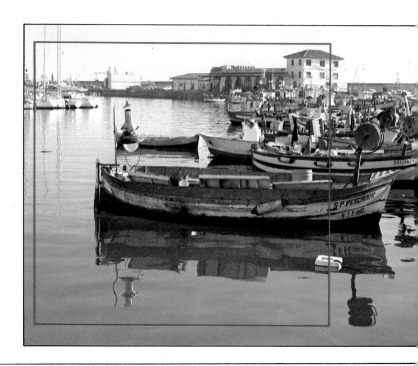

Right. *The first areas of color, created with faint washes of ultramarine blue painted over the lines of the initial pencil sketch. Notice that the wash of color describes not only the forms themselves, but also their reflections. In this type of painting, the reflections on the transparent surface of the water are just as important as the objects that produce them.*

Step 2. Atmosphere

As soon as the first step is complete and the wash of color has dried, try to establish the atmosphere that will pervade the painting, as Ferrón has done, following the stages we are about to describe.

He has used only very light touches of color in the sky and the sea. In the sky you will note a yellowish tone that was also applied to the upper third of the water. The blue tone of the two lower thirds has been enriched by the addition of more color.

Ferrón achieved two important things: By juxtaposing two planes of different shades and tonal values, he created a feeling of depth in the picture; and the luminosity of the cloudless sky, resulting from the introduction of yellowish tints, makes us feel that we are immersed in an atmosphere of radiance and light.

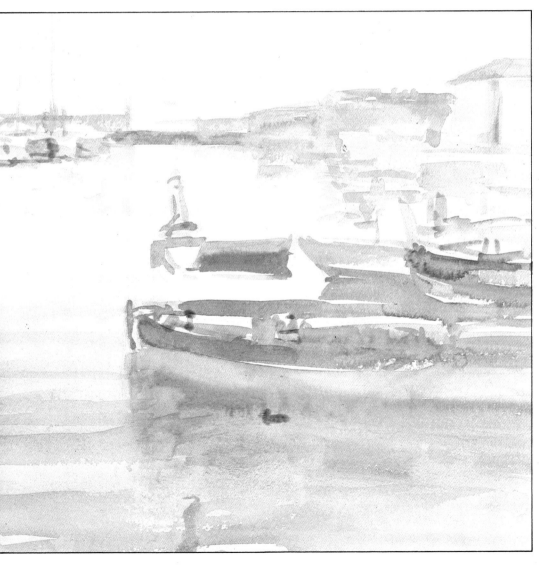

Step 3. Introducing new colors

Continuing to emphasize form through the application of different areas of color, we move on to the third stage. New, dilute colors are introduced, allowing the painter to retain the atmosphere created in the previous stage while increasing the richness of color. Maintaining transparency of color throughout the painting process (remember that this is one of the main qualities we wish to achieve) requires special care. We must not allow brushstrokes containing too much color to spoil our painting in the early stages of its development.

Step 4. Strengthening and adding further areas of color

On this and the next page we have set out a graphic summary of the processes our artist went through to achieve perfect color definition (in that each part of the picture was given the most appropriate color) and the correct depth of tone to create contrasts and to represent light.

Now, it is fairly easy to intensify color through successive layers of color, using brushstrokes that become ever more purposeful as the painting nears its completed state. In the close-up photographs, the enlarged view shows the freshness and spontaneity of these brushstrokes, to suggest color, rather than simply reproducing it. If this sounds like a platitude, you only have to ask yourself to identify the color of the boat in the foreground to see that it is not possible to give a definitive answer.

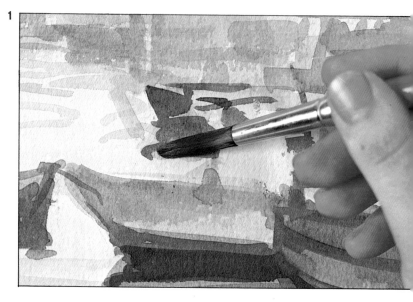

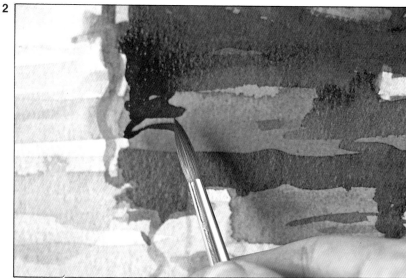

1. Two cinnabar green brushstrokes are enough to suggest the presence of a group of boats and their reflections.

2. The darker, more precise brushstrokes applied on top of the paler washes emphasize the illusion of transparency.

3. The background buildings have been "summed up" in a few brushstrokes that suggest the existence of architectural forms.

4. In this close-up it is clear that you have to "guess" the identity of some forms from just a few colored contour lines.

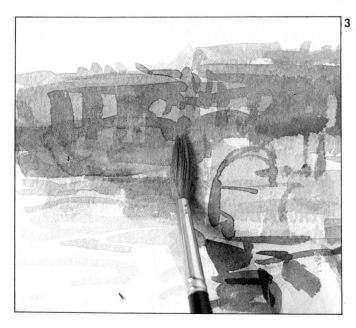

90

5. *Patch of carmine (rather more violet thanks to the blue background) intended to represent the reflection of one of the boats.*

6. *Moment when a brush loaded with blue starts to strengthen the color of the stripe along the upper edge of the foreground boat.*

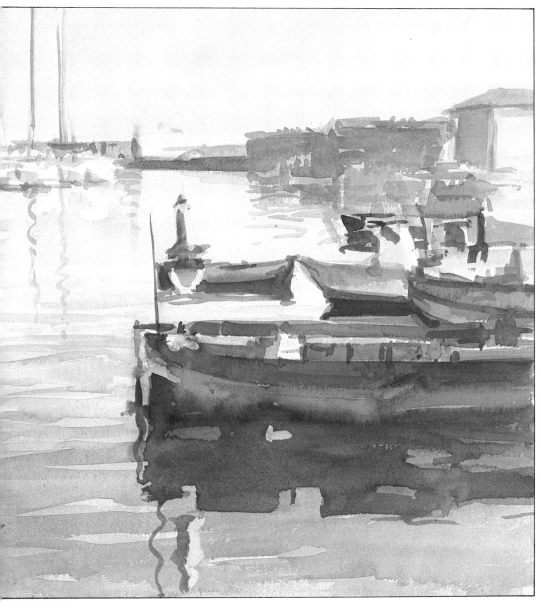

Left. *Ferrón's watercolor after the colors have been strengthened and the definitive contours established for each form and reflection. At this point, the artist has to ask himself, "How am I going to finish this painting?" One thing is sure: The boat in the foreground and its reflection looks a bit "dirty." The reflected image is too uniform and, as a result, the sensation of a liquid surface has diminished.*

Step 5. Completing the picture

Remember that we are attempting to produce a "color study" and not a definitive painting. To speak of the completion of a picture in this context implies reaching the limit of the possibilities offered by this subject. With this in mind, we should look at how the "finished" work on the next page differs from the image we achieved by the end of the fourth stage.

In the two photographs on this page, you can see that one difference involves including certain details, still with the intention of interpreting the subject in a free, uninhibited style. We still want to suggest, rather than illustrate. In the reproduction of the finished study, you can see that the foreground areas have been worked on more intensively. Color and form have been strengthened in this part of the picture, with fresh, confident brushstrokes that give character to the painting. Clearly, there is room for further work on Ferrón's picture, such as adding details, and clarifying certain ill-defined forms. However, in this type of study, the only intention is to convey atmosphere and light.

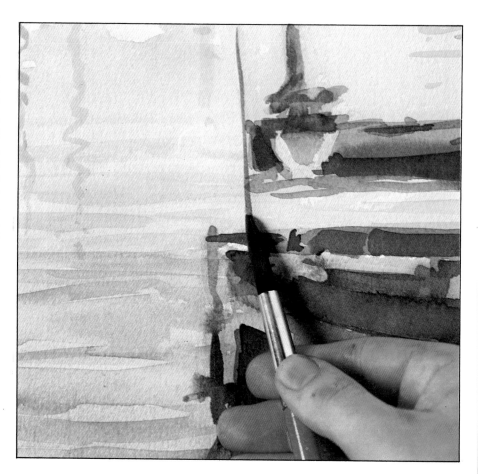

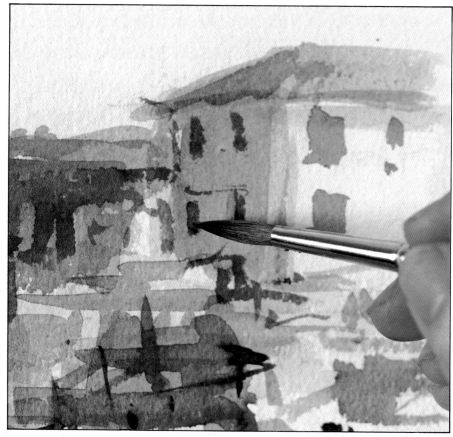

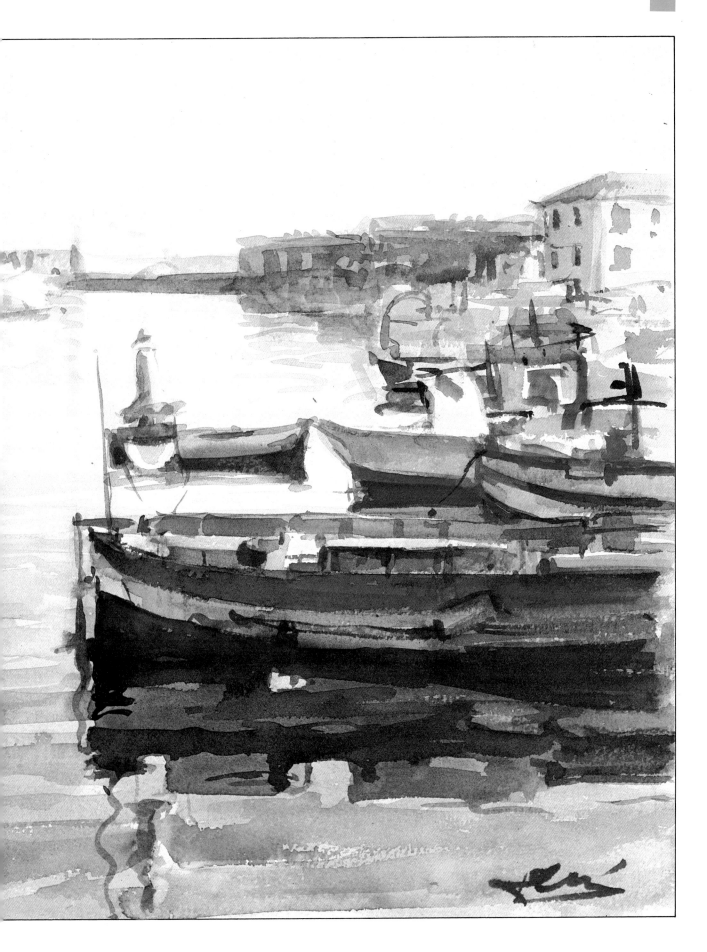

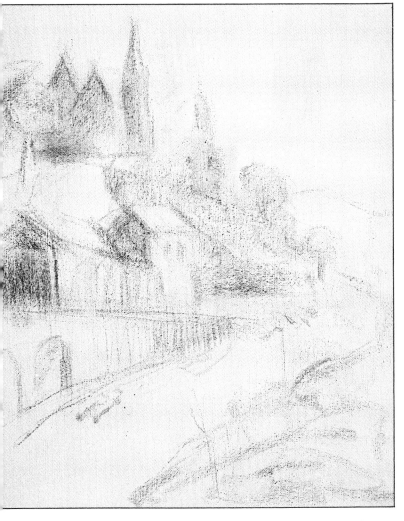

Often an artist can be on his way home after a session of painting in the open air, in the country or in town, when he chances upon something he finds interesting: A little corner of the town, a particular view of the landscape, the appeal of which he had not noticed before. Or perhaps some aspect of human life—a market, the excitement of a fair or carnival, or the atmosphere of a village square, captures his imagination. If it were not for lack of time and the inconvenience of transporting a second, recently painted canvas, he would want to record the moment immediately. What a shame to let that moment of inspiration go unexploited!

For times like these, it is a good idea to always carry a second, small canvas (one that fits inside the paint box) and five tubes of acrylic paint: The three primary colors, plus black and white. Add to this a piece of charcoal or a soft pencil, the brushes you normally use and some water, and you have all you need to produce a rapid sketch in color. First, working with only five colors allows you to have the palette ready in no time. And working with acrylics is a guarantee that, five minutes after the sketch is finished it will be dry enough for you to carry home, uncovered if there is no other solution, and without covering yourself with paint (or, for that matter, any other innocent soul who might be passing).

Above, left. *Charcoal sketch of the subject. The main elements of this landscape have been included.*

Left. *Application of a gray wash with which the artist, Pere Mon, dulls the surface of a canvas that he finds excessively white. This wash is, of course, optional. You may decide to do without it and go straight into the process described on the following pages.*

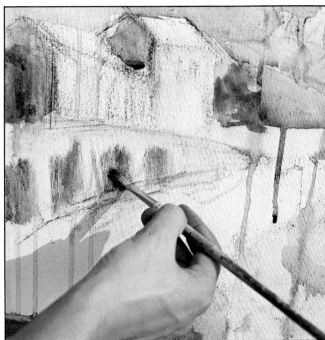

Working with a medium that dries quickly is very useful when making color sketches because it enables you to superimpose new colors without wasting time waiting for the first layer to dry. This means that you can work much more quickly than with other slow-drying techniques, with which you have to think about blending and mixing on the canvas or consider using thick applications of color.

Pere's example

On this occasion we have invited our friend, the excellent painter Pere Mon, to demonstrate how to produce a rapid sketch using just the three primary colors (as well as black and white) without sacrificing any purity of color.

With this aim in mind, we accompanied him to a spot at the foot of the Tibidabo mountain in Barcelona (which you can see on page 94), where he set up his easel and began the task summed up in the photographs and explained in the accompanying captions.

Top, left and right.
Reinforcing some of the charcoal lines that disappeared under the gray wash. Blocking in the dark areas of the subject with a black wash.

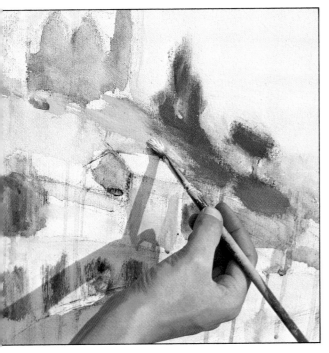

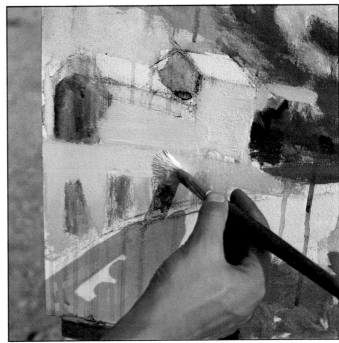

Your contribution

This time we would like you to imitate Pere Mon's approach, but not to copy his work. In this exercise you should imagine yourself in the circumstances we described at the beginning of this section. Find a subject that interests you and, using acrylics in only the three primaries, with black and white, jot down on a canvas no bigger than 16 × 10 in. (41 × 27 cm) the essential elements of your picture. Work as quickly as you can. This does not mean that you should work with a stopwatch beside you. Our intention is not to reduce you to a state of nervous anxiety (in which case it would be hard for you to produce anything worthwhile), but rather to make you think about what is essential when trying to make a simple sketch of a subject.

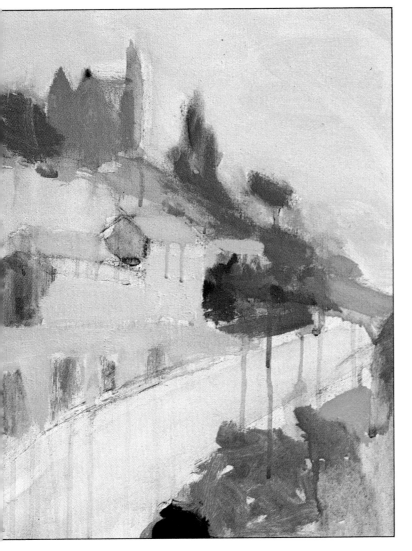

Previous page, below.
Overall view of the sketch after the black wash has been applied.

Above. Two close-ups showing the application of opaque color with wide brushstrokes in different areas of the sketch. The artist's aim was efficiency in covering as much of the surface as possible with a few brushstrokes, as illustrated in the second picture.

Left. The sketch after the first color was blocked in.

Right. *The artist at work.*

Below. *Two close-ups that capture two of the few occasions on which Pere Mon used a small brush. Even here, a single brushstroke has been enough to suggest the existence of the buttress-like structures on the containing wall seen in the left foreground of the painting. The same goes for the windows: Just one stroke with a fine brush and that's all there is to it!*

Next page, top. *Overall view of the sketch after the first, rapid blocking-in of color; a few more greens have been added in the lower right-hand corner of the picture.*

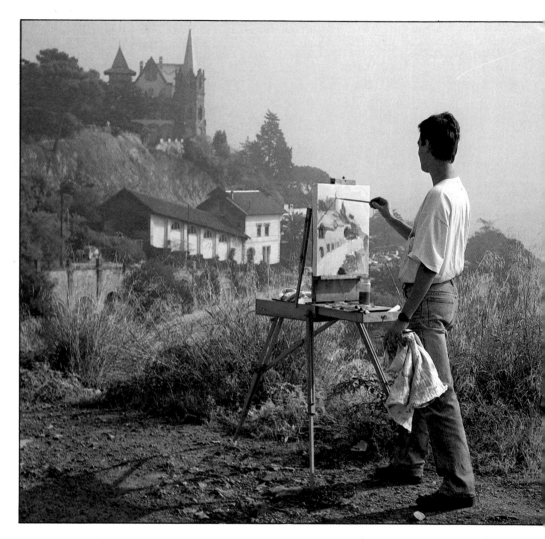

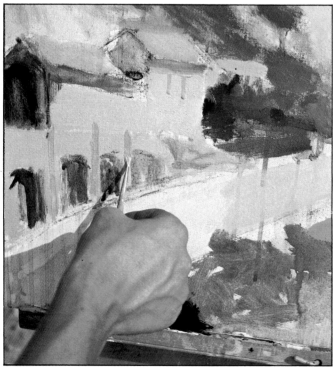

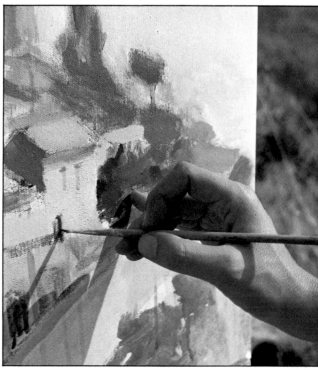

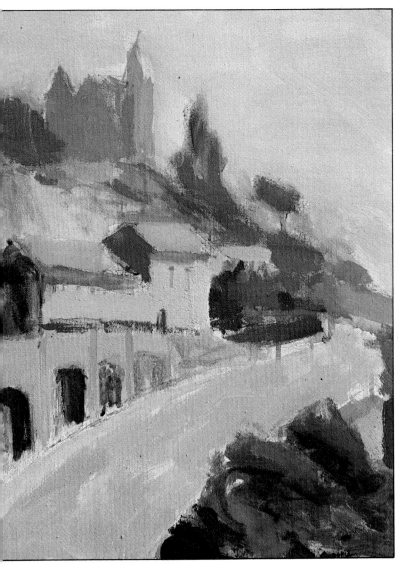

The saving in time does not result from the speed with which the brushstrokes are applied, but rather from the fact that there are fewer of them. Forms and colors are suggested with a minimum of effort. If something can be described with a single brushstroke, then we should make sure that we do not allow ourselves two. If a single color is sufficient for two or more areas of similar tone, there is no point in searching the palette for an almost identical shade within the same tonal range. When one stroke with a wide brush can cover a particular area, why waste time with a fine brush that will take three or four times the effort?

The art of the rapid sketch, contrary to what many people think, is not something for those who act without thinking, relying entirely on their intuition. As with writing, it is more difficult and requires greater concentration to say a great deal with a few words than to say little with enormous verbosity.

Think for a while about the comments we have made and then start painting—directly from nature if you can.

Below. Close-up showing how the green paint left on the brush can be used to reinforce the line between the road and the containing wall. The second illustration shows how the same brush and the same color that painted the wall of the building can be used to suggest a patch of light on the embankment in the bottom right-hand corner.

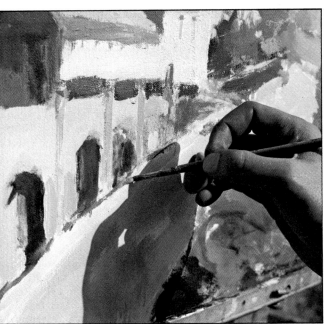

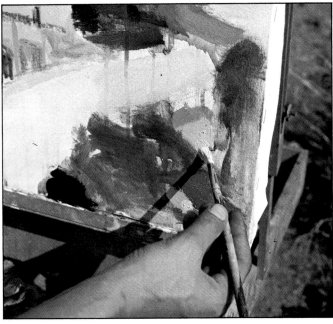

How do you know when to stop?

Deciding when a quick sketch may be considered finished is a difficult matter. Inevitably, ideas concerning what is a sketch and what is a rapidly produced painting differ. In principle, we can say that everything depends on the amount of time available.

It is obvious that if the artist had been able to take longer to produce the picture in our example, it would have had the more finished look of a painting, as nuances of tone were added and further details introduced. This would have occurred even if he did not lose the atmosphere of a sketch, or resort to colors other than those initially used.

There is no time limit. However, it is true that the initial approach to producing a rapid sketch using just the primary colors cannot be the same as when undertaking a premeditated work on which you are prepared to spend as much time as necessary. So, in principle, once a sketch has brought together enough elements to define the subject, we can say that it has accomplished its objective and may be considered a finished piece.

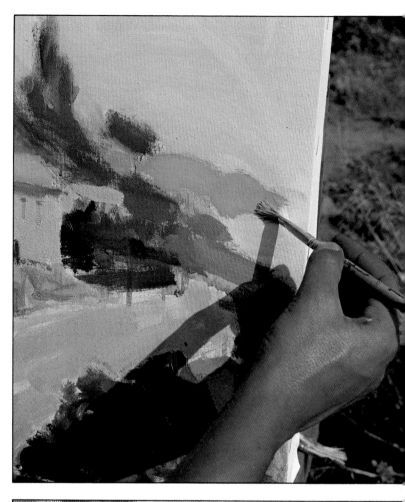

Right, above. Covering the mountains in the background with uniform color; this same color has been used for the palace facade (see top, opposite) and the roofs of the other building. The artist has applied the principle of minimum effort.

Right. Close-up showing the purity of the apparently formless strokes in this rapid sketch.

Next page. The completed sketch. A good example of how to convey a great deal with just a few brushstrokes.

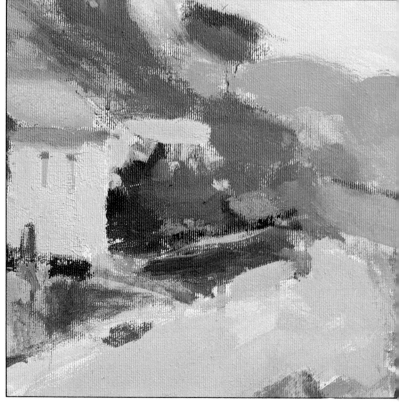

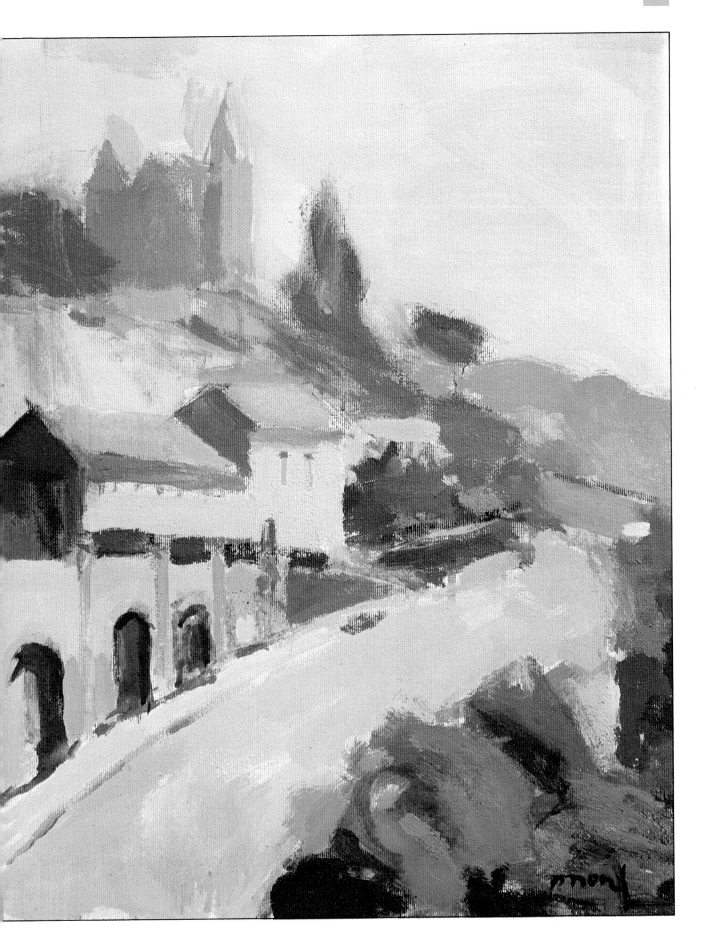

Using homemade acrylic paints

Although it is not a common practice, some artists, instead of using commercially produced paints, prefer to emulate the old master and prepare their own colors. We are not going to enter into a discussion of the relative merits of making your own at this point. However, we would say that every artist should, at least once, have the experience of painting a picture with colors he prepared himself. The process of choosing the pigments, mixing them with the appropriate binding agent, finding the right consistency and, finally, using the mixture to create a painting, is an experience that, like no other, gives us an intimate understanding of the medium. It develops our sensitivity to color, encouraging us to create our own range, different from those made by commercial manufacturers. This can undoubtedly give real character to our work. It is worth remembering some of the great artists who have distinguished themselves, among other reasons, for the originality of their colors. Think of El Greco's yellows, for instance, or Van Dyck's browns, or the greens of Veronese. Besides, the process we are recommending is no longer a difficult one, thanks to the existenc of practical binding agents such as acrylic. This is why the next exercise we propos involves preparing your own acrylics, rathe than any other type of paint. The raw acryli medium will allow you to experiment with pig ments easily and without a lot of mess.

To make your own acrylic paints, you wil need:

• Powdered pigment found in any specialt art store. The price of these pigments varies Pigments obtained from salts of chromium, fc instance, are more expensive than the earth pig ments, including ochre.

As for which pigments to buy, you will hav to invest in the basics: A blue (ultramarine) vermilion, and cadmium yellow. White is als essential, although black is an optional extra You might extend your range with a green (c several, such as emerald and cinnabar green) an ochre, raw and burnt sienna, raw umber, an so on.

• Raw acrylic medium, also found in ar stores. The binding capacity of this substanc depends on how much water it contains

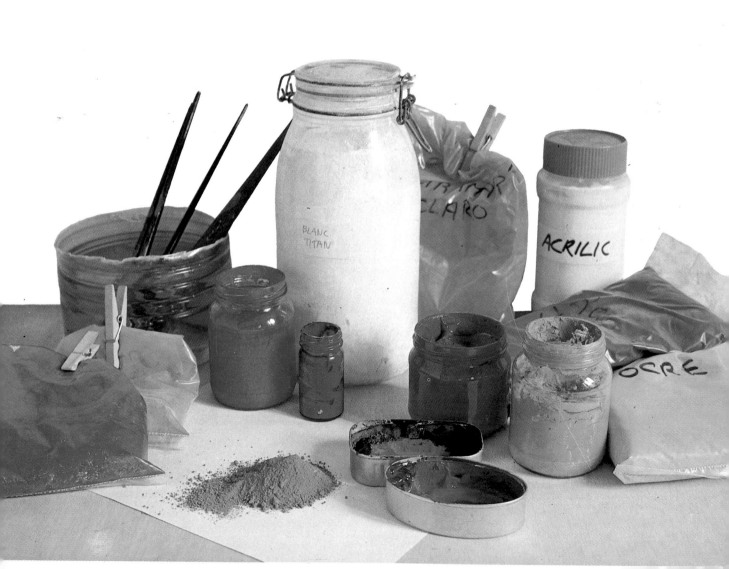

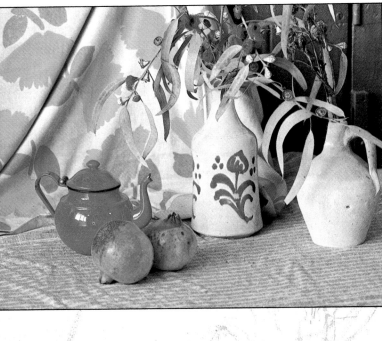

Logically, its effectiveness as a binding agent will disappear if there is too much water in the mixture. As a general rule, the relationship between acrylic medium and pigment, in volume, should be 50/50.

• Spatulas. You should have two or three wide, strong spatulas to make mixing pigment and acrylic medium an easy job.

• A varnished wooden board or a thick sheet of glass on which to mix your paints. If you opt for the wooden board, varnish it so that it loses its porousness.

Left. Sketch of the subject that Muntsa Calbó has painted for us using acrylic colors she has mixed herself. She has painted the sketch directly onto the canvas in a yellow-orange color, complementary to the tone that will be dominant in the painting (violet-blue). Because it is a light color, the paint applied later will cover it easily.

Below. Close-up pictures showing the first areas of color being applied. Strokes with a wide brush block in the ochres, violets, and pinks of the patterned cloth in the background. Muntsa Calbó told us she always has to make a mental effort not to launch into the picture with very bright colors (those that attract her most) but to restrain herself, first applying the pale shades that become a guide to the intensity of color to be added later to the canvas.

*This page. Photos show-
ing the restraint the artist
used in developing the
color scheme.
Except for the luminous
red of the tea pot, which
is an uncompromising
vermilion, the violets,
blues, and ochres have
been softened through the
addition of white, giving
them a greater opacity. In
the large photograph, the
vases are described in
just a few, muted brush-
strokes, with no strong
contrasts. They show sub-
tle variations of tone,
similar to those of the
drapery, which prevents
them from stealing the
limelight.*

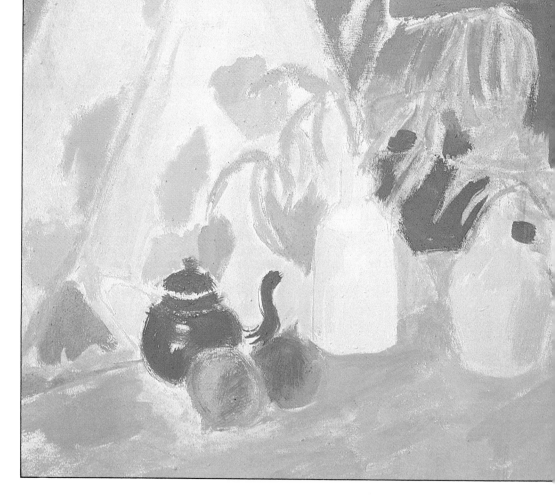

• Glass jars with hermetic seals for storing the paints you have made up. It is much more practical to prepare a reasonable amount of paint and to keep it, than to be constantly mixing small quantities. We recommend you make up a fairly thick mixture that you can cover with a little water to protect it from contact with the air. If the jar is tightly sealed, your acrylics should last a long time.

Preparation

Pour a little acrylic medium (tablespoonful) onto your wooden or glass surface. Beside it, place an equal amount of your chosen pigment.

Slowly, to avoid spilling the powder, carry a little of it to the acrylic medium and press it in with the spatula. Then pick up the medium that has spread out and press it into the pigment again. The idea is to mix the pigment until you have a thick, uniform paint of a regular consistency. While using the spatula to blend the mixture, and whenever it starts to become too thick, add a few drops of water to make it more fluid.

When you have prepared the first spoonful of paint, add another spoonful of acrylic medium and another of pigment, and continue to mix it using the spatula. It is quite difficult to mix large quantities all at once, so it is easier to do it in stages. Gradually add ingredients until you have the amount you need. As this is a trial run, don't prepare too much.

Left. Close-ups showing some luminous strokes that stand out strongly from the other more subtle colors (of the eucalyptus leaves, for instance); the quieter colors form a halo of diffused light around the more dominant tones.

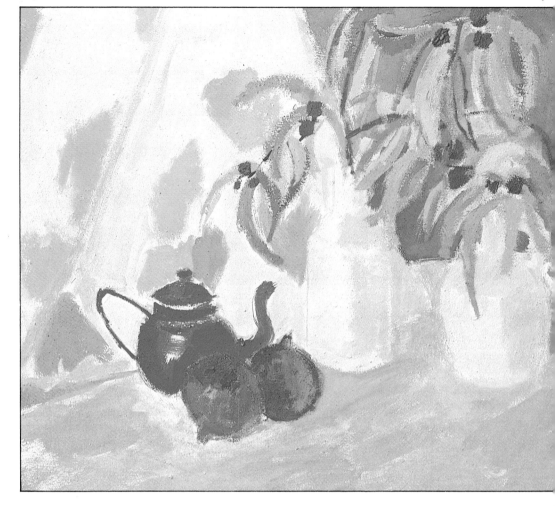

Right. The picture after the main areas of color have been established. In spite of the chromatic impact of the teapot, the curved lines of its handle and spout lead the eye toward the two vases.

Below, and next page. Four close-ups showing a few aspects of the artist's work that speak for themselves.

Using your paints

Your acrylic paints will dry fairly rapidly once in direct contact with the air. For this reason, we recommend that you only take out of the jar as much paint as you will need.

In the photograph on the left, you can see that Muntsa Calbó works with equipment that, although rather unconventional, allows her plenty of space for mixing her colors (the strip of plywood). To have room to lay out all the colors ready for mixing, she has given a new lease on life to an old wooden table from her own kitchen.

It is important that a minimum amount of time elapse between mixing the colors and applying them to the canvas because of the speed with which homemade acrylics dry. Naturally, colors diluted with water dry more slowly. The appearance of an artist's workplace reveals a lot about his or her style of doing things. Muntsa Calbó's studio indicates a very direct and intuitive style, and the aesthetic pleasure the artist gains from contemplating and exploring color for its own sake, even though on the canvas she may be interpreting a specific theme.

A few final tips

In general, the pigments produced by commercial manufacturers are finely ground enough to be mixed without any kind of preparation, especially if the binding medium is acrylic. If you wish to make oil paints rather than acrylics, the technique is more or less the same, although it becomes more important that the pigment be finely ground.

The best binder for oil colors is refined linseed oil. The pigment is mixed with the oil (using, in volume, half as much pigment as linseed oil, or even less). Blend patiently until you achieve the consistency you require. As linseed oil dries very slowly, it is common to add a little cobalt pigment and oil of turpentine to accelerate the process. The proportions in which these components are added depends greatly on the tastes of the individual artist. It is best to experiment until you achieve the right drying time for your style.

However, remember that oil painting is intended to be a slow-drying process. An excess of drying pigment or turpentine can lead you to produce very low-quality, thin, and lifeless paint that cracks easily.

Do make the effort to prepare your own colors; it is a constructive exercise that, we should emphasize, does much for your understanding of, and sensitivity toward, color.

Below. Close-up showing Muntsa Calbó's last few brushstrokes on her painting. She felt that the fruit located nearest to the foreground did not stand out enough, so she emphasized its contours with a broad outline of cobalt blue.

Right. The finished picture. Note how the subtle harmony of the dominant shades (violet-blues) is exploded by the color of the teapot and the yellow patches near to it. However, because they do not take up much of the overall volume of the picture, they provide an effective contrast within the chromatic uniformity of the composition.

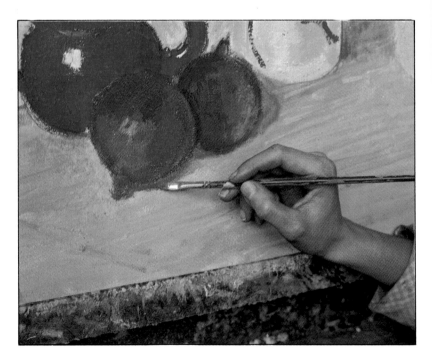

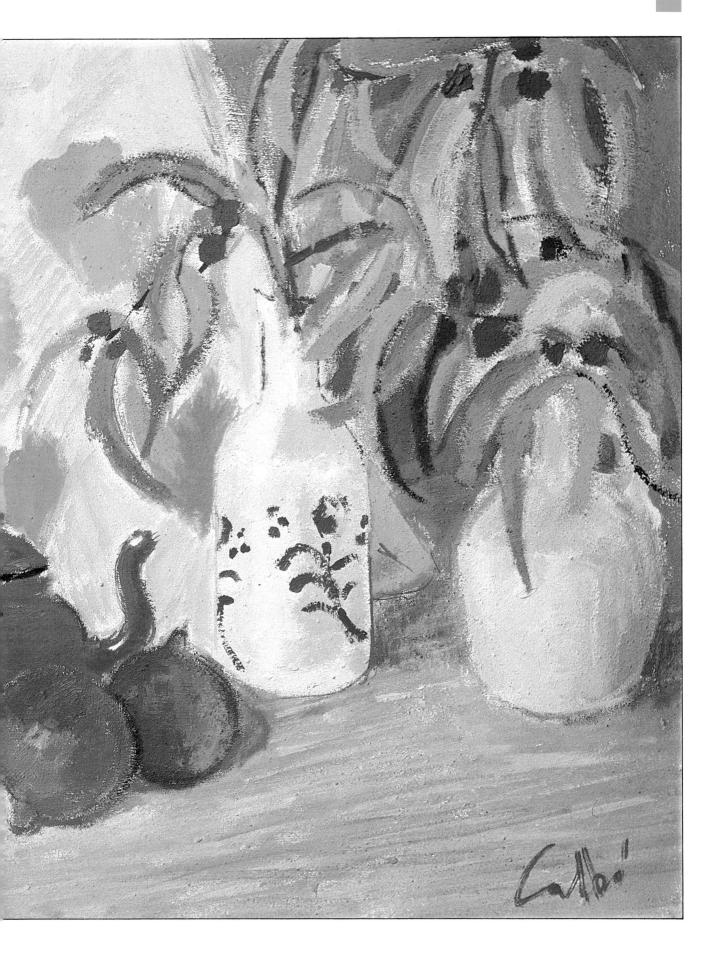

Acrylics. An urban landscape

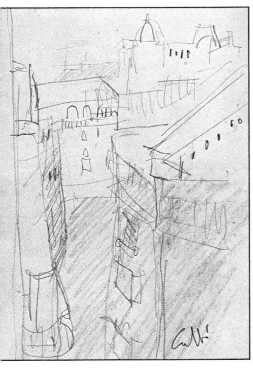

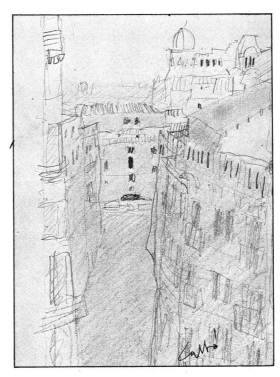

Left. Two outline sketches (the second of which is more detailed) drawn in a simple, uninhibited style, in which the large area of shadow covering the lower half of the subject has been roughed in. In the definitive picture, Muntsa Calbó has tried to retain the spontaneity of these two sketches.

Below, left. Sketch on canvas, based on the second of those shown above.

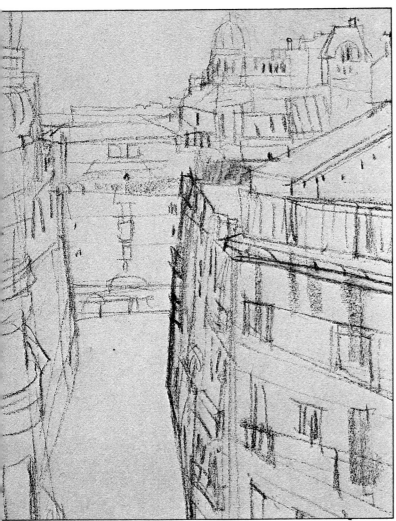

The difficulty of being spontaneous

On the previous page is a photograph taken from the terrace of Muntsa Calbó's studio in Barcelona. This is the subject she is going to explore for us in the next exercise. Her objective is to create a pictorial image, based on an immediate and spontaneous response to the initial visual impact of what she sees. The idea is to approach an urban landscape (or any other subject) with the mentality of a child, who would find it much more important to put what he sees into the drawing than to apply the objective adult criteria of perspective and theory of color. Subordinating your artistic training to a kind of conscious spontaneity is harder than the beginner might imagine.

The outline sketch

On this page you can see the result of the first important decision taken by our artist: The sketch applied to the canvas was taken from the earlier sketch rather than from the subject itself. It has been drawn with a clean, freehand line, without deferring to the laws of perspective.

Transparent background color

Our artist knew that if she made her sketch on canvas directly from nature rather than from another sketch, she would have fallen into theoretical considerations. These may have enabled her to produce a more accurate representation of form, but at the sacrifice of the main aim of her painting: To convert the subject matter into a spontaneous image of an aspect of the city that, although very familiar to her, she was seeing through new eyes. The resulting image is unorthodox, but valid by virtue of its spontaneity.

Just as she has tried to avoid conventions of form, she has also refused to make a meticulous investigation of color, wishing this aspect of her painting to be equally spontaneous. With this aim in mind, she decided that the first areas of color to be applied should be primary and transparent ones, distinguishing between illuminated parts of the picture (warm colors) and areas of shadow (cool colors) through complementary shades. Muntsa Calbó determined to use blues (ultramarine and cobalt) to indicate shadow, and ochres and yellows for the illuminated portions of the picture.

Using these areas of transparent background color as a base (see the next page), the artist adds further layers of color, not so much to alter the shades themselves, but to define the different planes. She plays constantly with the warm-cool contrasts of light and shade.

It is worth noticing how Muntsa Calbó suggests forms by defining new planes on top of those already established; for instance, the sienna-colored roofs, balconies, skylights, and so forth, are conveyed by a few fragmented strokes that give an idea of their true form.

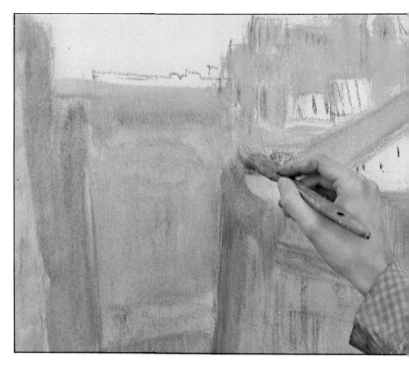

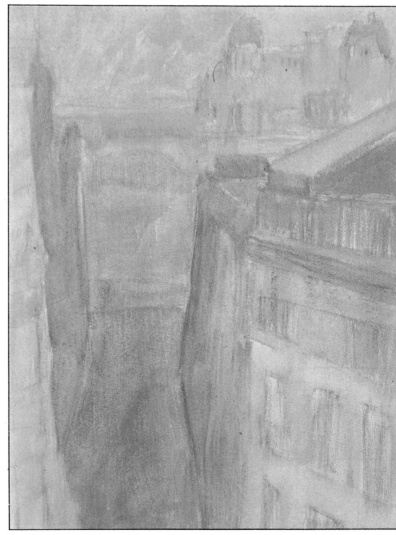

Above, right. Close-up of the initial layout of the painting, after the cool areas have been laid in and during the stage in which the artist is blocking in the illuminated (warm) areas using ochre mixed with white. The addition of white is not just to lighten the color, but also to make it more opaque.

Right. The painting once the transparent background color has been applied, determining the general base tone on which the richer colors will be built up. Without this first stage, the initial impression of color that influenced the artist would have been lost.

Above, left. Close-up of the sloping planes of the roof indicated by fragmented brushstrokes of raw sienna applied on top of the ochre background color.

Left. Tone of one of the walls in shadow, showing a more luminous blue than that initially applied as background color.

Above. Changing the background color of the facade of the building in the right-hand foreground. Muntsa Calbó has changed the initial blue to a warmer tone and is now experimenting with a pale bluish green.

Left. Blocking in the smallest areas of shadow with a single stroke of pale cobalt blue. Notice in this same close-up, the pictorial interest developed in this area of the picture by contrasting the warm and cool colors and by the subtle tonal variations made to the ochres and siennas.

Details

In the type of painting we are creating here, attention to detail may seem rather incongruous. If any artist goes out of her way to avoid excessive detail, it is Muntsa Calbó. However, it is possible to represent a subject using large planes of color and still suggest the details of a wall, a roof, a street through tonal variations of the main areas of color without abandoning these stylistic criteria.

It is clear that Muntsa Calbó's picture, as it appears at the end of the previous stage, tells us very little about the particular spot she is painting; at most, it describes the arrangement of a street, a few walls, and some roofs.

What Muntsa Calbó now intends to do is to breathe life into these structural elements by suggesting the presence (call it detail, if you like) of doors, windows, balconies, blinds, and so on.

In these two pages you can see how she has achieved this: For each detail she has tried to find a graphic representation that somehow synthesizes its basic form or essence. Without realizing it, this is what children do when they draw and they often present us with true masterpieces of graphic symbolism. However, if you study these photographs carefully, you will appreciate that Muntsa Calbó's work is childlike in appearance only.

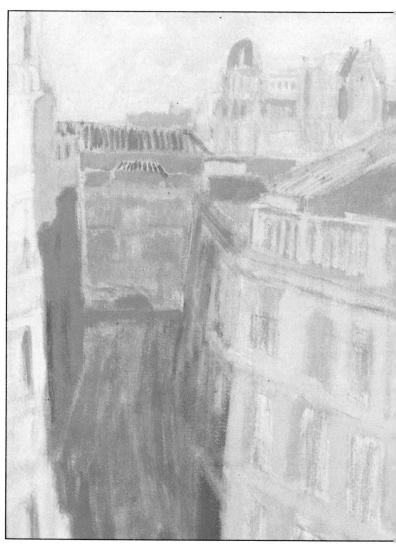

Above, right. Muntsa Calbó's painting before she has started working on the elements we describe as details.

Right. Using vertical and horizontal brushstrokes applied with a round, hogs' hair brush, the artist has suggested doors and windows with the simplest touches of Prussian blue mixed with a dab of black.

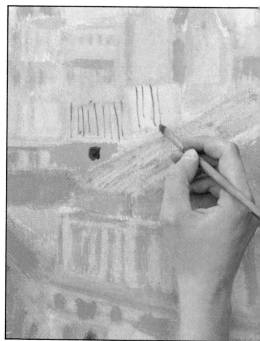

114

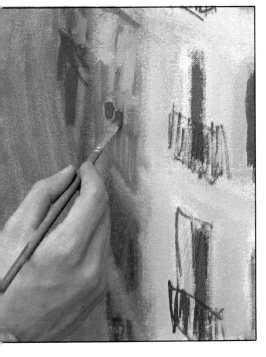

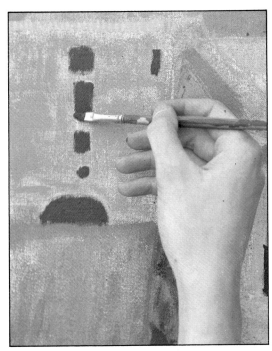

Left. *Flower pots on a couple of the balconies are suggested with the slightest touches of deep red. Nothing more is needed to indicate the existence of these flower pots: It is not necessary to describe them in detail. A few rectangular and circular marks are enough to suggest the existence of openings in the facade of the building facing us.*

The strokes that suggest the balcony rails or the parapet of the first building, for instance, are carefully judged, "adult" graphic representations.

You undoubtedly are starting to understand why we began by describing "the difficulty of being spontaneous." Often, it is harder for an artist to suggest a form than to describe it in detail. Our adult mentality, which has stored so much information about familiar objects, more readily grasps the detail than the global picture; we find it easier to define the individual railings of a balcony than the balcony itself. Our attention is drawn more easily to particular details than to the personality defined by a combination of characteristics. We'll say it one more time: It's difficult to be spontaneous in art!

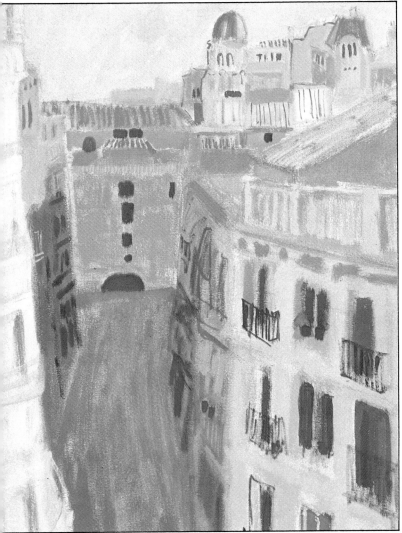

Left. *Muntsa Calbó's picture, ready for the final brushstrokes. Notice the importance the building in the background on the right has assumed, thanks to the blue lines describing its outline and, also, to the impact of the domed roof and the four-sided sloping roof to its right. Both of these have* *been reinforced with a deeper tone of blue. The appearance of the picture changed after the addition of some brighter colors to its facade. Now the structures have become homes rather than just empty buildings.*

115

The final brushstrokes

Our artist has reached the stage in her work when it is time to step back and decide what else is needed before the painting can be considered finished.

Muntsa Calbó, after applying her critical eye, reached the conclusion that a few more strokes were still needed.

Compare the photograph on the previous page with that of the finished work (opposite): The flats along the street have been darkened with Prussian blue, making the buildings look bolder and more luminous; the colors of the terraces on the right have also been strengthened and particularly important is the layer of blue shadow across the lower half of the facade directly facing us. The facade of the building has also been built up with tones of ochre tinged with blue.

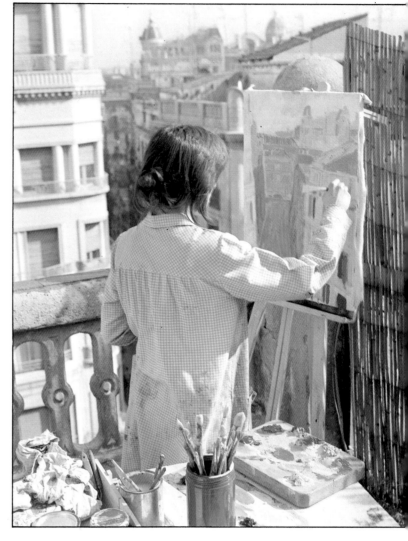

This page. The artist at work. Below, two close-ups showing the application of the layer of blue across the facade of the building directly facing us and, secondly, the flat brush "illuminating" the upper edge of the parapet.

Opposite page. Muntsa Calbó's work in its completed state. The apparent lack of inhibition in the drawing and the equally free brushwork make this painting a good example of what practicing the "art" of spontaneity can produce.

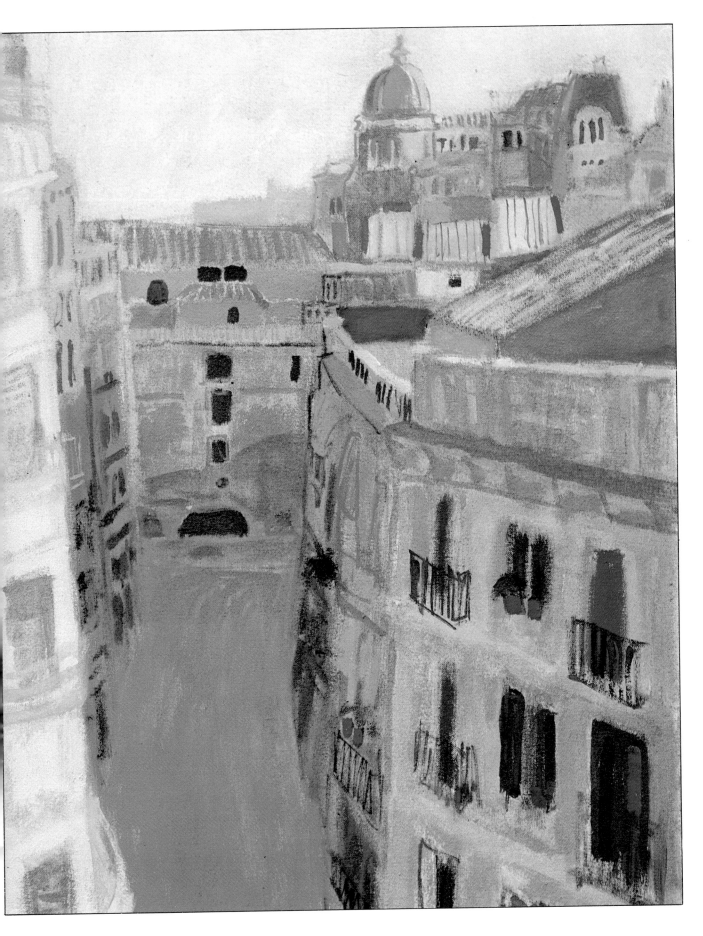

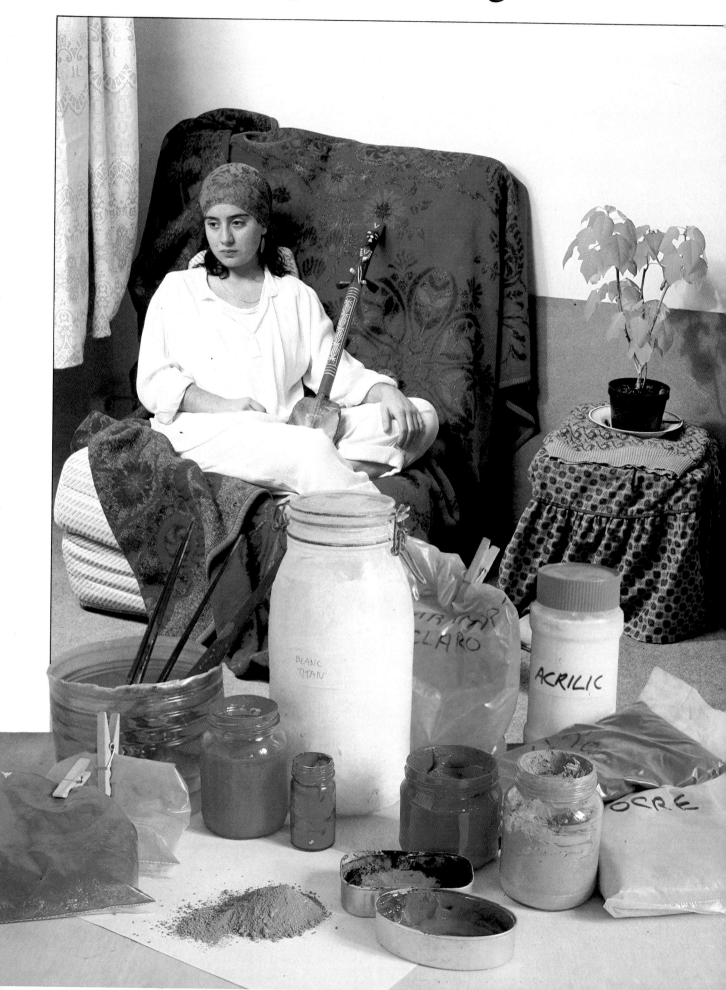

General comments

The next practical demonstration shows the development of a painting of a model using acrylics on canvas, with colors prepared by the artist herself, Ester Serra.

The pigments used are red and ochre iron oxide, titanium white, manganese blue, ultramarine blue, molybdenite red, and phthalocyanine green.

Ester Serra has used the traditional method: She has drawn an initial charcoal sketch that has been fixed so that she can apply a general layer of red iron oxide, thin enough to allow the charcoal lines to show through. With medium-sized hogs' hair brushes, she has blocked in the general tone of the composition and the individual tone of each of its elements, working with even and fairly opaque strokes.

Acrylics in general, especially homemade ones, are opaque and dry, even parched-looking. For this reason, Ester Serra complemented the brushwork with areas in which she created transparent veils of color by rubbing a cloth across the picture surface.

Above. Sketch of the subject. Notice that the artist's aim is to locate the main forms and their inner rhythms without going into too much detail.

Left. Photograph showing the initial sketch being fixed using an aerosol fixative. If you look closely, you will see the traces of an earlier sketch capturing the model from a more frontal position. This first sketch did not satisfy the artist and, after erasing it, she decided to move a little to the left. From this new angle, the composition follows a sharper diagonal, making it less centralized and more dynamic.

Right. *Two interesting close-ups: In the first, the artist is blocking in a layer of red iron oxide. She is doing this with a good-sized flat brush and with the canvas lying flat to prevent the paint from running. In the second, a rag is being used to remove color from the forearm of the figure. What Ester Serra is actually doing is restructuring the drawing around various negative planes.*

Right. *The picture after the first layer of color has been applied and worked over with the rag. Notice how the negative planes have given a greater sense of volume to the figure.*

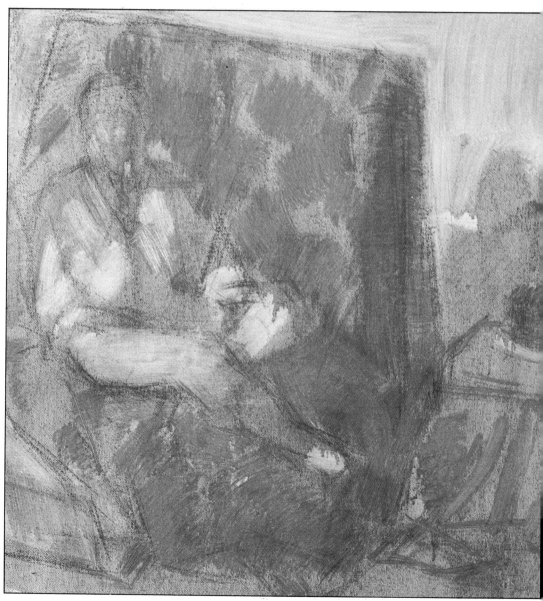

What really makes this picture original is the vibrancy that the colors take on thanks to the initial layer of red oxide present everywhere in the painting. Naturally, we are not suggesting that you try to paint exactly like Ester Serra, who has her own highly individualized style of painting. As we have stated many times before, these step-by-step demonstrations by the various artists are carried out in their own style and they claim to do nothing more than show you different concepts of painting. These may or may not coincide with your personal vision, but their pictorial value cannot be denied and it should be possible for you to gain from each one idea you can develop according to your own style and criteria.

Left. Using green oxide, the artist is experimenting with a few early contrasts between subtle colors, suggesting the damask backcloth behind the figure. These apparently random brushstrokes, seen as part of the overall picture (next page), describe the quality of the drapery and also provide a necessary coolness to contrast with the mass of warm tone dominating the composition.

Below. First touches of white on the figure. Notice that the first brushstrokes have outlined form and indicated the main creases in the clothing. To describe as "white" the tone used in this painting is something of a misnomer. There are no pure whites at all; the titanium white used here has taken on distinct tinges of ochre.

__Right.__ Overall view of the picture after the main areas of color have been blocked in. This is the result of the individual actions described on the previous page: The touches of white, ochre, and green oxide, and the addition of the blue tones of the turban and the little cloth beneath the flower pot.

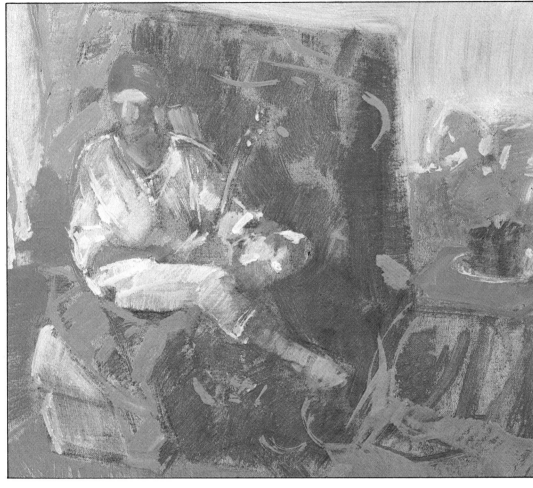

__Right.__ Close-ups illustrating three points during the picture process: Outlining the outstretched leg with ultramarine blue (A); applying pure red color to the drapery (B); and pale ochre and grayish ochre with green oxide to the first layer of color on the wall in the background (C).

A

B

C

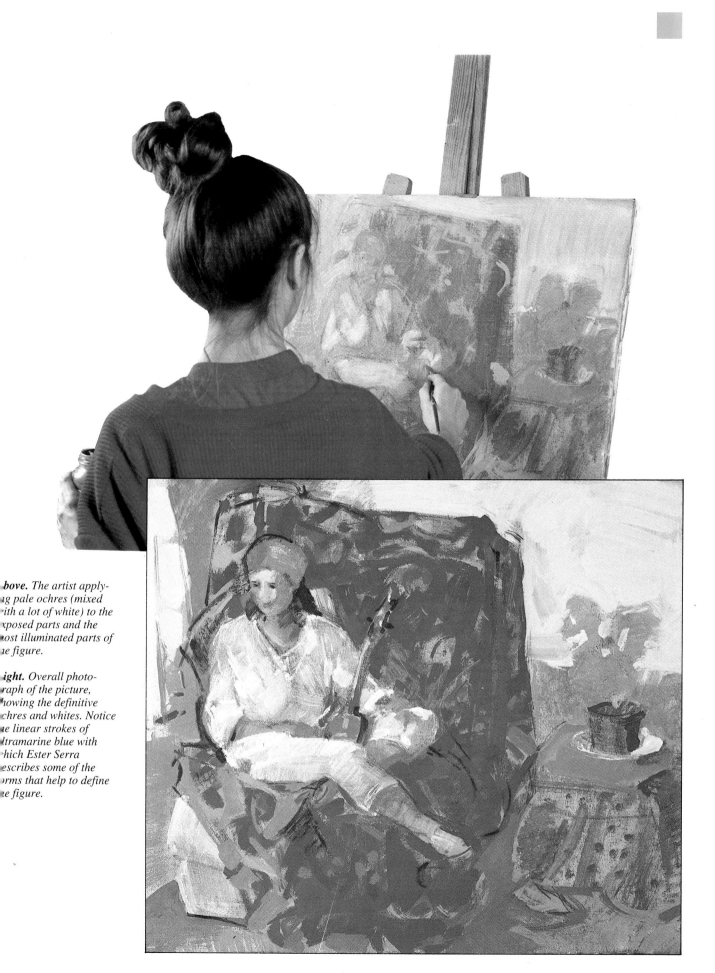

*bove. The artist apply-
g pale ochres (mixed
ith a lot of white) to the
xposed parts and the
ost illuminated parts of
e figure.*

*ight. Overall photo-
raph of the picture,
owing the definitive
chres and whites. Notice
e linear strokes of
ltramarine blue with
hich Ester Serra
escribes some of the
rms that help to define
e figure.*

123

A final word

What exactly do we expect from you in this section, how can we justify describing Ester Serra's picture as part of an exercise?

Put another way, how should you respond to the impression this painting may have made on you? Of course, there are many things we could ask you to do. For instance, we could ask you to make a faithful copy of Ester Serra's painting—why not? We could also ask you to find another model and to make a painting in your own style using acrylics you have made yourself. However, we consider that the greatest benefit following Ester's example derives from exploring, through your own work, the phenomenon of the optical fusion of colors when seen from a distance.

So our request, then, is that you create a picture designed to be seen from a distance, even if you have to break from your customary style in order to do so. Are you ready to start?

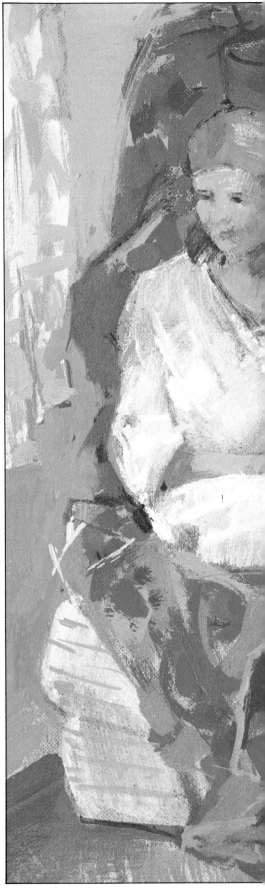

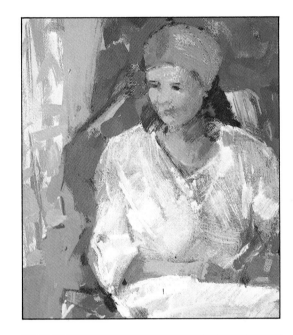

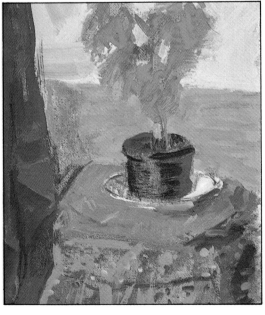

Right. Close-ups which show the extraordinarily free (very impressionistic) brushstrokes that, when looked at closely, do not attempt to describe formal details. However, when the painting is seen from a distance, because of the optical fusion of color, atmospheric and chromatic effects are produced of considerable aesthetic value and interest.